Michelangelo

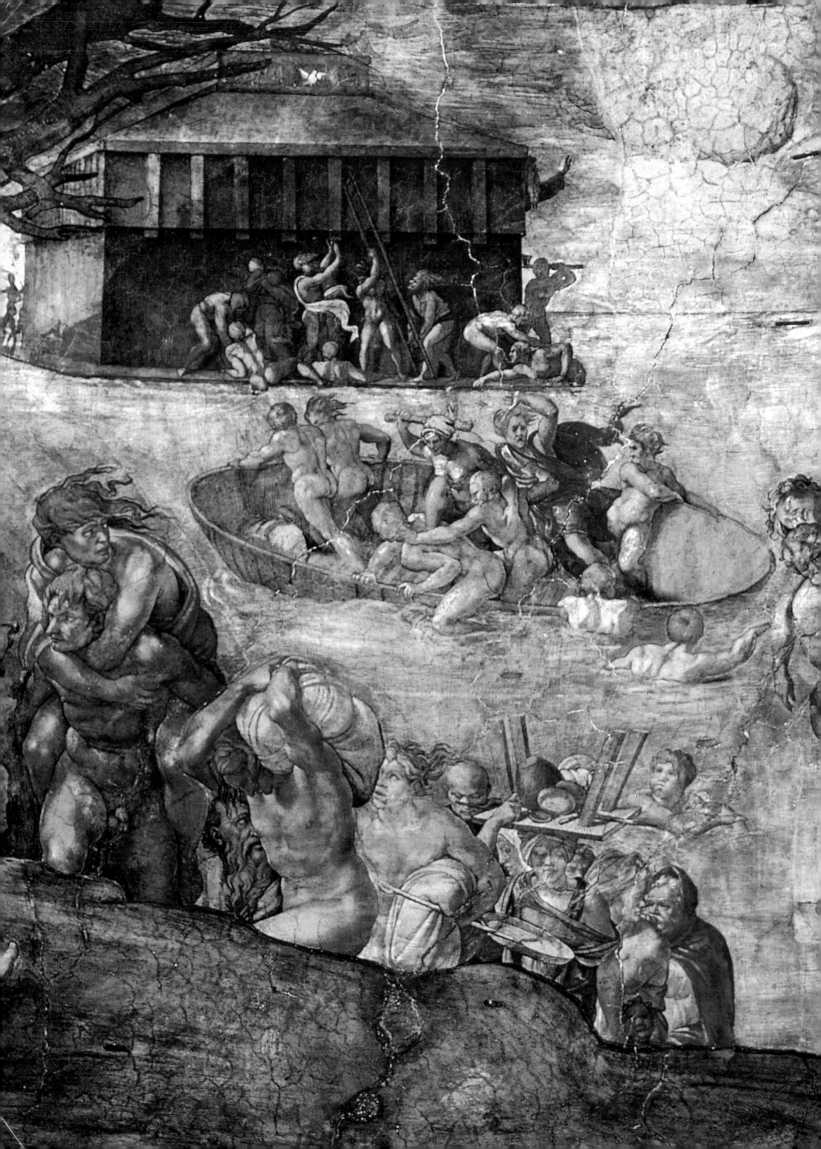

Michelangelo

Trewin Copplestone

GRAMERCY

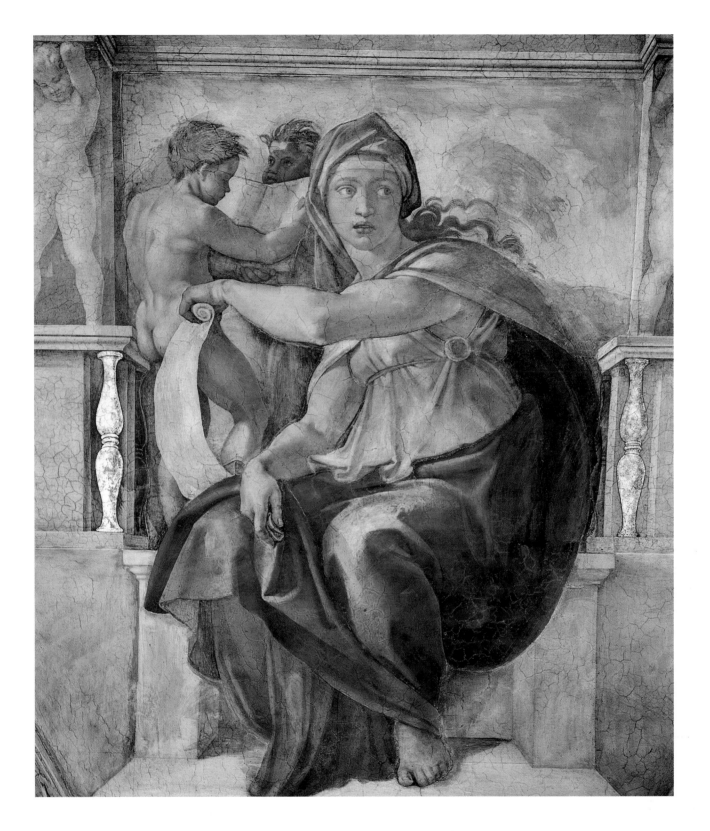

This 1998 edition is published by Gramercy Books, a division of Random House Value
Publishing, Inc., 201 East 50th Street, New York, NY 10022
Gramercy Books and colophon are trademarks of Random House Value Publishing, Inc.

Random House New York • Toronto •London • Sydney • Auckland
http:// www.randomhouse.com/

Printed in Italy
ISBN 0-517-16058-7

10 987654321

Printed in China

List of Plates

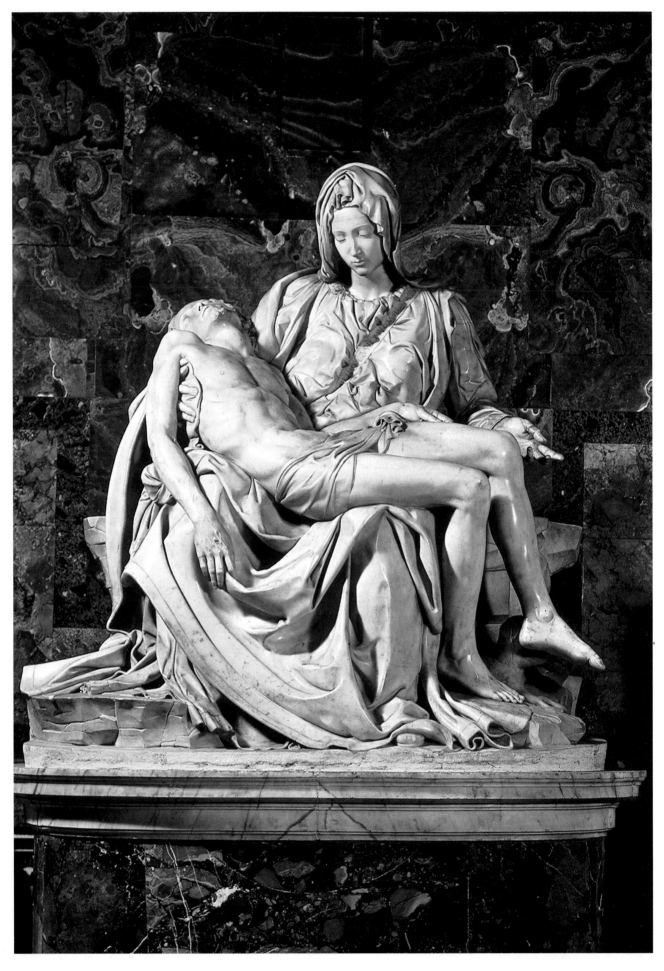

PLATE 1

Pietà (1498–99) St. Peter's, Rome

Marble, 69 inches (175cm) high

Commissioned in 1497, this was Michelangelo's first religious commission and the only work he signed. This indicates the importance he attached to receiving so prestigious a contract at the age of only 23 when he was already famous. Allied to this was the fact that the work was destined for St. Peter's, the most important church in Christendom, where the work has remained though moved to different locations in later centuries. It is now in the first chapel on the north side of the basilica. Michelangelo's identification with the work is boldly stated in the band across the chest of the Madonna. It is indeed an extraordinary work in its emotional depth and technical assurance; that it is the work of so young and inexperienced a hand must surely be a measure of Michelangelo's developing genius. The sculpture is made from a block of marble, originally oval in shape, as can be seen from the base, and the surface is finely polished with modelling that is both acute and sensitive. The youthful figure of the Madonna holding the body of her son, newly removed from the cross and appearing little younger than his mother, adds to the pathos of a mother surviving the death of her son. The figure of Christ is a brilliant expression of Michelangelo's already deep knowledge of human anatomy, seen in the clear lack of muscular tension in what is, after all, a dead body.

From his early 20s, Michelangelo was regarded with much the same amazed respect by his contemporaries as he is today. It is not unusual that, as tastes change in different periods of history, the reputations of almost all creative figures should from time to time seem to diminish. The value and regard in which Michelangelo is currently held, although chewed over by critics, has hardly been modified by the general viewing public in the near half-millennium that has passed since he died. He was considered by his contemporaries to be the greatest genius of modern art – that is of the Renaissance – the equal, if not the superior of the great masters of the arts of Greece and Rome. And time has confirmed his pre-eminence in all three of the so-called fine arts of painting, sculpture and architecture. His influence, subsequently, makes him a yardstick by which the qualities of Renaissance-inspired art have been, and still are, judged. This admiration and respect does not, however, inevitably entail enjoyment and contemporary relevance. Many find it possible to have the greatest regard for Michelangelo, to recognize his extraordinary powers, his superhuman energy, his unrivalled technical assurance and unique intellectual creativity, without experiencing the same feelings of affection that lesser artists inspire. If this is the case it is a pity, and it is in the hope that a real understanding will result in increased pleasure in Michelangelo's work that this book is written.

With many artists, the course of their art is a mirror of their lives, reflecting both experience and response in a visual form that relates directly to personal events. Such artists as Rembrandt, Velásquez, Gauguin and Van Gogh present such a response. With Michelangelo, it was not so. His life was that of an artist-craftsman who followed a bourgeois lifestyle, was prone to selfishness, and was irascible and secretive towards those with whom he was in ordinary contact. In his art, painting, sculpture, architecture, and his often unacknowledged poetry, he sought an heroic elevated plane in a superior world of the spirit. A conflict existed, and when the time came to make a choice between the flesh and the spirit, it was the exalted spirit that invariably triumphed.

Michelangelo was a giant in an age of great men; his stature was not the greater for the absence or paucity of other great contemporary figures. The 15th and 16th centuries, in which he lived his nearly 90 years, saw the Renaissance flourish and the foundations of modern Western society laid. It was an age of great events, great figures and great achievements in science and the arts. Michelangelo grew up in one of the most energetic, creative, intellectually active periods in history and in an Italy that was at its centre. Just to list his contemporaries in the arts in Italy establishes something of this vibrant activity. One only has to mention, for example, artists such as Leonardo da Vinci, Raphael, Bramante, Botticelli, Piero

PLATES 2 (detail right) and 3 opposite
Bacchus (c. 1497)
Marble, 72½ inches (184cm) high

Probably commissioned by Cardinal Riario but rejected by him, the work was bought by Jacopo Galli, a Florentine banker who had created an 'antique garden' for his sculpture collection. It has been described as obeying the classical canons but it is clearly a pseudo-antique as would have been evident at the time. In a drawing of the garden in about 1532–35, Bacchus' right hand was seen to be missing but, by 1553, had been restored, probably by Michelangelo. There can be little doubt of the subject: it is the classical god of wine, grapes forming his headdress, and he raises a cup of wine. He is supported by a satyr and the hedonistic voluptuousness of the figure's pose is subtle but unmistakable. It might be noted that even in this early work (probably before the Pietà – plate 1), Michelangelo exhibits a classical freedom which even Donatello or Verrocchio, his great predecessors, never managed to achieve, and it is this that first distinguished him as a genius of the 'modern' classical world.

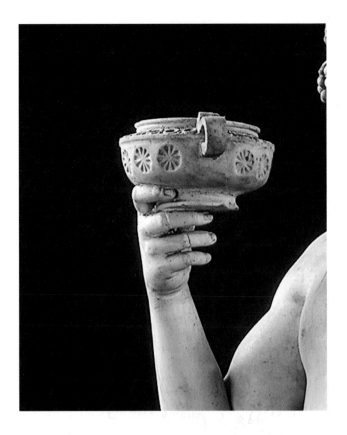

della Francesca, Ghirlandaio, Verrocchio, Titian, Tintoretto, Veronese, as well as the humanist philosophers, Pico della Mirandola, Giordano Bruno, Poliziano, Marsilio Ficino and, to put history into perspective, Shakespeare, who was born in the year of Michelangelo's death, 1564.

In order to evaluate Michelangelo's achievement in the context of this age of great achievement, it is of the utmost importance to have an understanding of the nature of Renaissance society, culture and political structure, as well as its historical progress. Difficult as it is to explain the great and extraordinary outbursts of periodic energy that have occurred throughout history, the Renaissance is one of the most significant in the formation of Western thought, a time of unique constructive creativity. The subject is too large to be considered fully in the confines of this introduction, but some major aspects demand comment. This is perhaps particularly important at the present time when history is not always given the importance that it surely deserves.

The bedrock of early Western society is to be found first in Greece and subsequently in Rome as civilization moved west from its cradle in the Middle East during several centuries before the birth of Christ. What was initiated by Greece in the form of architecture (the most immediately perceptible art), philosophy, literature, science and, perhaps most significantly, politics was hastened in its

development as Rome first conquered and then absorbed Greece and its culture, spreading subsequently further west and north to include most of the then known Western world. It remains a model, an exemplar to which we can still turn for solutions to a wide range of modern problems, from political structures to ideas for decorating pottery.

The rise of Christianity in later Imperial Rome and its spread by the Empire through all its lands, led to its adoption by Western society, deflecting interest from the earlier classicism so that it was nearly 1,000 years later, for political reasons, that a return to classical themes occurred. Interest quickly turned to enthusiasm and passionate dedication to understanding, reconstruction and re-evocation.

There is still much discussion as to the earliest evidences of this renewed interest in the classical world and it is important to note that interest did not drown during the growth of Christianity, it merely submerged and, so to speak, held its breath. The timing of this return depends on what are considered to be the qualities that represent Renaissance society. Academic consideration of this matter is continuing and perhaps it is sufficient, for the moment, that we recognize that Michelangelo was born at a time when classical culture was capturing minds and souls and nearing its purest apogee.

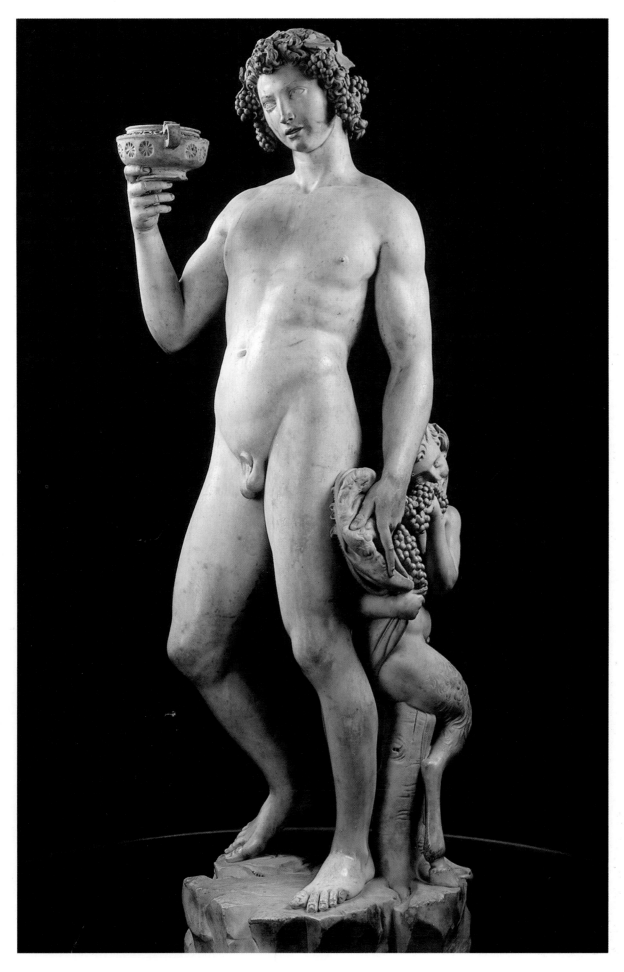

PLATES 4 and 5 detail opposite
David (1501–04)
Marble, 161½ inches (410cm) high (including the base)

The story of the marble block from which the sculpture was created is well known and is briefly recounted on page 29. The commission was for a sculpture which would stand on a buttress on the Florence duomo but when finished was considered too fine and dominating a work for such a relatively obscure location; eventually, after advice from masters of the older generation, including Leonardo, Botticelli and Perugino, it was placed in a public location where it would be seen by the whole population. The site chosen, in front of the Palazzo Vecchio in the main Piazza della Signoria, where a copy still stands, could hardly have attracted more public attention. It became, for the people of Florence, a symbol of her importance in the culture and life of Renaissance Italy, a country at that time composed of a large number of independent city-states.

The large scale of the work was not a new departure for Michelangelo who had completed a larger figure of Hercules, since lost, who was a recognized symbol of Florence and whose head had appeared on coins. Nevertheless, the authority of the modelling and the anatomical assurance of the carving indicate the extent to which Michelangelo was studying and absorbing the principles of human anatomy. He had already made dissections of corpses and Vasari, his biographer, recounts how an early crucifix made for the church of Santo Spirito was in payment for a room in which the operations were carried out. The block of marble destined for Michelangelo's figure had already been used but abandoned by two other sculptors, Agostino di Duccio and Antonio Rossellino, and it was no little achievement in itself that Michelangelo managed to complete the whole large figure from such a forbidding and damaged volume of marble. The intended buttress location would have placed the sculpture high above eye-level and Michelangelo's solution had allowed for this, following classical precedures by enlarging proportionally upwards so that from below it would look correct. Placed nearer eye-level, this deliberate distortion makes the sculpture appear slightly 'top-heavy'.

The original sculpture suffered damage during political disturbances in 1527 when a chair, thrown from a window in the Palazzo Vecchio, broke its left arm in three pieces; nevertheless, the figure was not removed from outside the palazzo until 1873 when it was transferred to the Accademia.

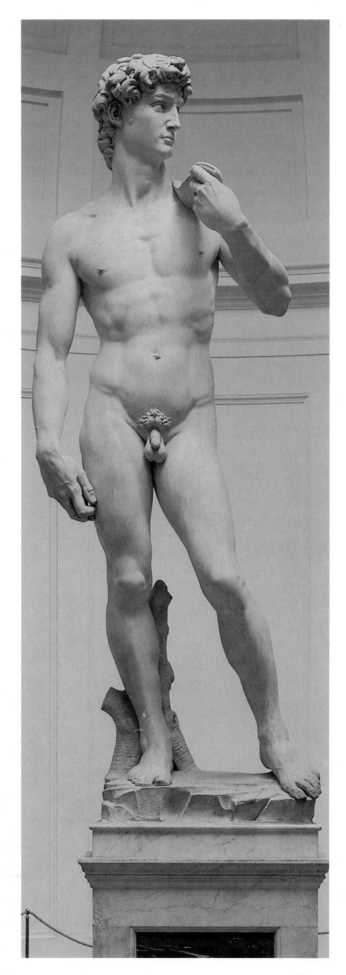

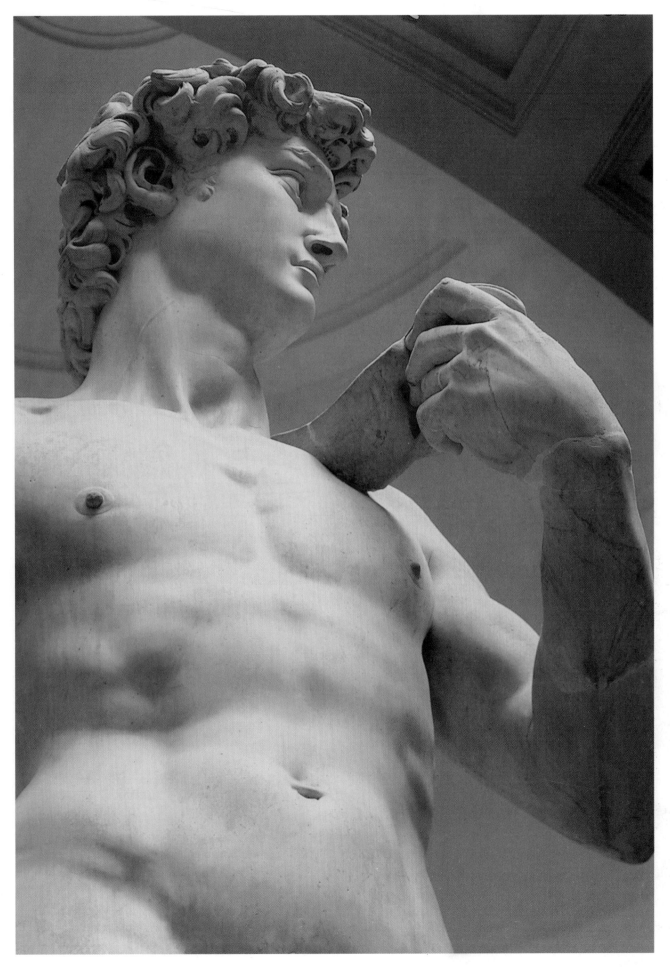

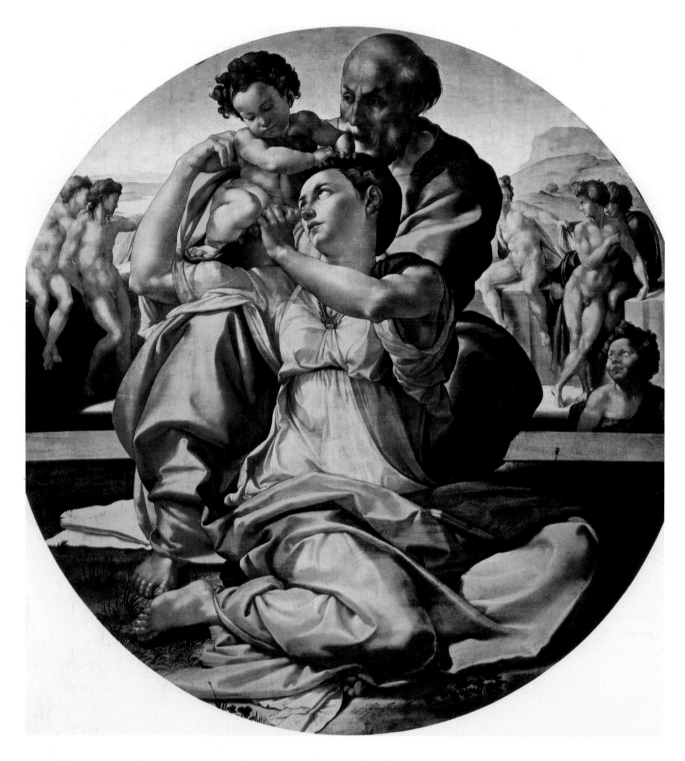

PLATES 6 and 7 detail opposite
The Holy Family (The Doni Tondo)
c. 1503–04

Tempera on panel, 47½ inches (120cm) diameter

A great patron of the arts and a successful merchant, Agnole Doni commissioned Michelangelo to make the panel, in all probability as some form of celebration or commemoration of his wedding to Maddalena Strozzi in the winter of 1503; but he did not accept it and a lengthy dispute over payment ensued. This is the first known painting by Michelangelo and he is already displaying the classical linear style that he adopted in the Sistine ceiling. Even as a young man, his personal identification with the classical inspiration is evident in the incongruous nude youths in the background, a foretaste of the ignudi *on the ceiling. The background of open sky and the anonymous foreground are also typical of the later Michelangelo, while the dividing band across the middle-distance suggests the separation of the classical from the advent of Christianity. The painting is in tempera, a difficult method involving the creation of an emulsion of water and oil through the agency of a natural emulsion, usually egg.*

PLATE 8 right
Madonna and Child with St. John (The Taddei Tondo) c. 1505–06)
Marble relief, 46¼ inches (117.5cm) diameter

This work was commissioned by Taddeo Taddei, hence the name. Although it is an unfinished work, it is an unusual and dramatic composition. The contemplative figure of the Madonna contrasts sharply with the active Child whose back provides a strong, curving near-horizontal across the centre of the relief, while the unfinished figure of St. John as a child provides a stabilizing vertical to parallel the main compositional base, the Christ-Child's leg. The panel was bought in Rome in 1823 by Sir George Beaumont, one of the founders of the Royal Academy, to which he later donated it. There remains some doubt regarding Michelangelo's authorship of the tondo (circle); scholars are still not unanimous in their agreement that it is his, some believing that it may have been worked over by another hand, some that it is the work of a follower.

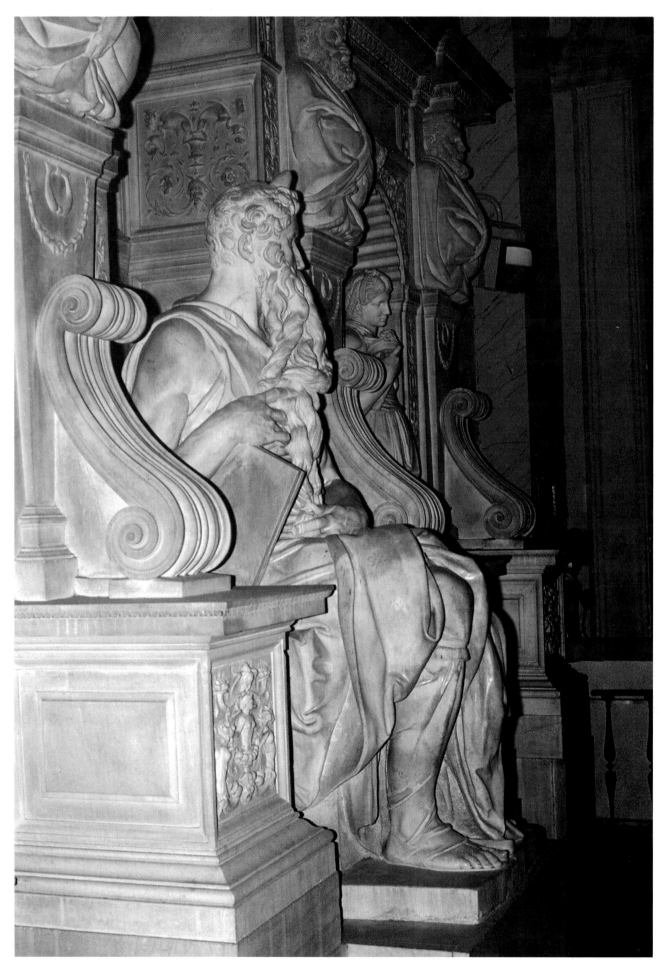

PLATES 9 (opposite) and 10 detail below

Figure of Moses (Tomb of of Pope Julius II – uncompleted project) 1505–45)

Marble, 100 inches (254cm) high

Michelangelo's own view of this great commission to provide a funerary monument for one of the Renaissance's typically energetic and culturally inspired popes was expressed much later when the full impact of its troubled course was finally evident. Michelangelo considered that he had wasted the whole of his youth on the tomb and he had certainly spent much time amending and redesigning it as his contract was redrawn six times, the dimensions of the project shrinking on each occasion. Over 40 figures and four large bronze reliefs were originally intended for the two-storey freestanding mausoleum which was contracted to take five years to construct. In the event, it was still unfinished after 40 years and Michelangelo had completed only a few of the intended figures, of which the Moses is the most powerful. The figure was intended to be one of four large seated sculptures on the upper storey, but this was the

only one completed. In May 1505, Michelangelo went to Carrara to order the marble which, when delivered, caused a financial crisis in the Vatican because of the enormous volume required. The pope had already committed himself to an even larger project, the rebuilding of St. Peter's, and the tomb receded from centre-stage. Michelangelo was furious and returned to Florence. Other sculptures, both finished and unfinished, and destined for the tomb were: 1513–16 Moses, Dying Slave (plate 12), Rebellious Slave (plate 13); 1516–34 Victory (plate 14), Youthful Slave, Bearded Slave, Atlas, Awakening Giant; 1542 Leah, Rachel.

Some of the architectural details of the tomb were designed by Michelangelo for the final structure which was placed in San Pietro in Vincoli, Rome and not in St. Peter's as was originally intended. Not all the work by Michelangelo was included, while the work of other hands was used to complete the mausoleum. The slave figures finished up in different locations, the Victory, still in Michelangelo's studio on his death, being later placed in the Palazzo Vecchio, Florence. PLATE 11 below shows an engraving of the projected design for the tomb.

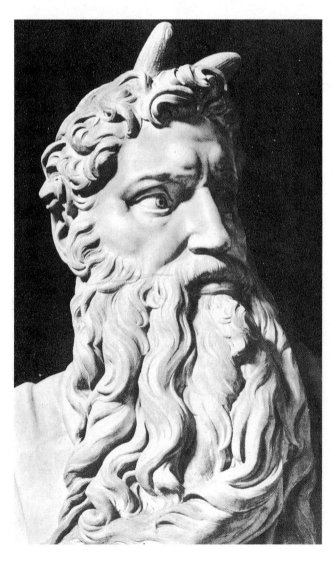

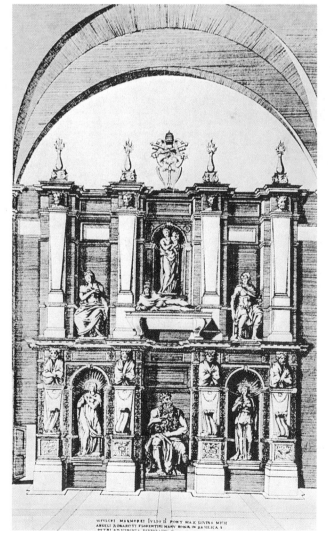

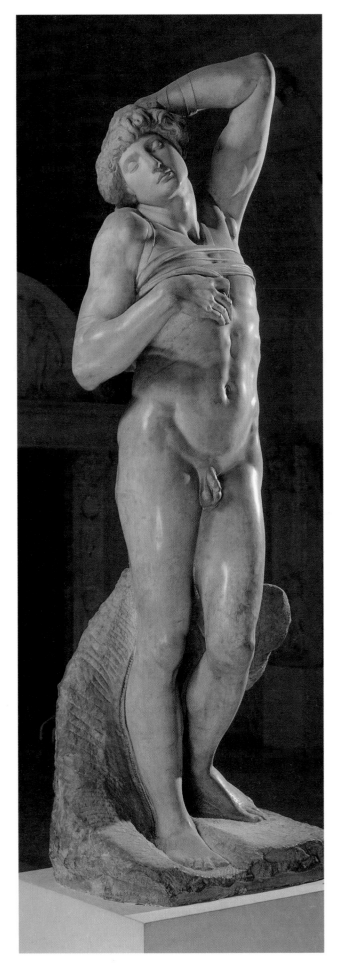

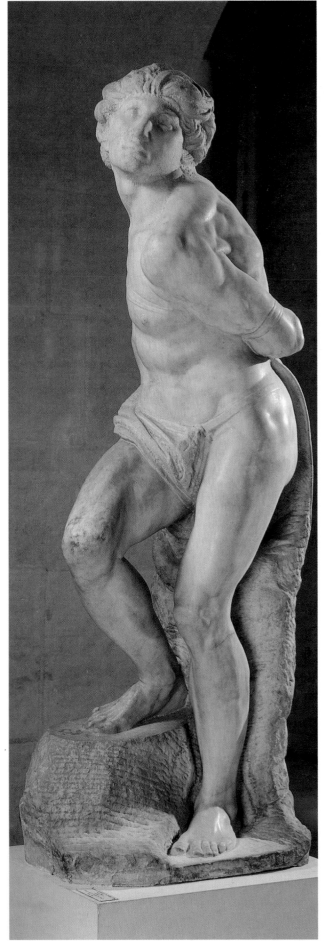

PLATE 12
Dying Slave (c. 1513–16) opposite left
Marble, 108 inches (274cm) high

The several figures of slaves intended for the tomb of Pope Julius II are in varying stages of completion and the Dying Slave is finished to a polished degree that enables one to judge Michelangelo's intention regarding the other unfinished works. Nevertheless, these are among the most powerful expressions of the concept of terribilità that is associated with his name. The superhuman scope of Michelangelo's vision is revealed in the direct carving of the stone, executed with an energetic frenzy as though to release rather than create the form that is trapped within the block. In their unfinished state the slaves have a poignancy that suggests that Michelangelo actually felt in their imprisoned forms the struggle for a freedom never to be regained.

PLATE 13
Rebellious Slave (1513) opposite right
Marble, 85 inches (216cm) high

This uncompleted figure identifies the continuing struggle of life itself, and the upward yearning glance of the unyielding spirit in the mature figure of the slave indicates, perhaps, a plea for divine intervention in his despairing human situation. (One may recall that it was designed for the tomb of Pope Julius II with whom Michelangelo had many personal struggles.) In the emerging form of the lower body from an amorphous block of marble, one may note the power of both Michelangelo's spirit and his technique.

Renaissance culture was the inspiration for a re-examination of the nature of Christian civilization in relation to the condition of man, to his spiritual health, his intellectual limitations and possibilities and, particularly, to the philosophy of the ancient world as reflected in a Christian community. Divided loyalties between devotion to Christianity and intellectual curiosity concerning the classical civilizations resulted in a compromise between a Platonic pagan humanism as distinct from a Christian spiritual imperative, God or Mammon. As the Renaissance developed, parallels were emotionally discovered between the new Italian Renaissance states, each dominated by a city, and the city-states (*polis*) of classical Greece: Florence seen as a new Athens. As we shall see during the examination of Michelangelo's career, the qualities of classical (both Greek and Roman) art and architecture were absorbed into the arts of the Renaissance. The sources based in classicism were proudly displayed, and subjects which had become almost exclusively Christian in inspiration during the previous centuries began to be discovered in the classical history of mythology. The treatment of both Christian and classical subjects was part of the programme of most painters and their treatment of, say, the Madonna and Venus, syncretized in such a way as to make them virtually indistinguishable from one another. Such a comparison may be drawn from Botticelli, Michelangelo's contemporary. The whole eventual effect of this was to concentrate interest in the individual personal treatment of subject-matter, rather than the subject-matter itself. One important result of this was an increasing awareness of a cult of personality and by extension personal fame; for example, a painting of a Crucifixion by Raphael or Leonardo drew its quality from the artist rather than the subject; it became Raphael's Crucifixion or Leonardo's. When, like Michelangelo, an artist is recognized as proficient in all the arts it is not perhaps surprising that he achieves ascendancy. But even this does not explain Michelangelo since others, Raphael for instance, were also recognized masters in more than one art form.

We are only concerned here with the period of Michelangelo's lifetime, although it was a long one of almost 90 years; but the influence of classicism, once established in Renaissance Italy, continued to dominate the aesthetic life of Western society until the end of the last century and still holds a modest role in this. The criteria of classical excellence were established in the 15th and 16th centuries and one of the dominant influences on these was Michelangelo. As will, however, emerge during consideration of Michelangelo's life, he created an essentially personal classicism to parallel his devout Christianity, which had a great impact on later periods in other countries of Europe.

When Michelangelo was born on 6 March 1475, at

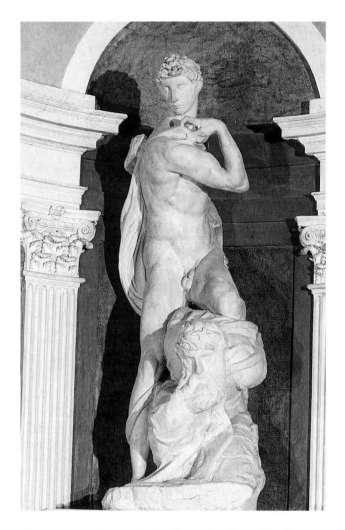

PLATE 14
Victory (c. 1519)
Marble, 103¹/₂ inches (263cm)

Although it seems certain that the Victory was intended as one of two on either side of the central door of the Julian tomb, it has been noted by some scholars that it is more in feeling with the work in the Medici Chapel which was also of greater interest to Michelangelo as the tomb project became increasingly troublesome and irksome. It was probably made at the same time as the Medici Madonna. On his death there was some notion that it should be sited above Michelangelo's own tomb but was eventually placed in the Salone dei Cinquecento in the Palazzo Vecchio. The strong turning figure in deliberate spiral form carries incipient baroque implications, later fully expressed in Bernini's energetic David. Its open expressive gesture of supremacy is also turned in to a binding swathe of capture for the head of the captive on whom Victory kneels.

Caprese, a small town in the Casentino about 35 miles (56 kilometres) south-east of Florence, the Renaissance was already far advanced. The term itself is self-explanatory: renaissance means rebirth, implying the re-emergence of what is already pre-existent – in this case, of course, the classical cultures of Greece and Rome. The study of classical topics, from documents to monuments, became an intellectual passion in the local centres of Italian culture, in city-states such as Florence and Milan, in the republic of Venice and even in Rome itself, the headquarters of the Christian church. Humanist philosophers were beginning to threaten or question the whole Christian ethos; even the church itself was beginning to be infiltrated by humanism through all levels of the priesthood to the Holy Father himself, particularly in the later period of the High Renaissance.

Italy was not a single unified nation-state but an aggregate of a number of differently structured self-governing entities. Some, like Florence, were nominal republics but were often dominated by powerful families; some like Milan were dukedoms, governed by despots who had, in the main, imposed themselves by force of arms. Across the centre of Italy was a band of small municipalities governed by the Church of Rome and consequently known as the papal states. These were controlled by papal forces and at least one pope spent more time fighting than performing his pastoral duties as Christ's vicar on earth. An exception to these systems was the republic of Venice which was an oligarchy governed by ten families from whose hereditary rulers the head of state, the doge, was elected. At the courts of the dukes, among the wealthy entrepreneurs of the republics and the great houses of the higher clergy – bishops, cardinals and even popes – the intellectual life of Italy was fostered and nourished.

So remote from the ordinary life of the populace did the clergy become that it was largely by the devoted efforts of the humbler levels of the priesthood that religious life was sustained and cherished. The effect on the character of the different states that constituted what we now know as Italy was highly varied. From the earlier centuries, two traditional historical loyalties still remained as part of the social structure and provided a basis for fierce rivalry between the different states. The two sources were the papalists of the Church of Rome and the imperialists (Holy Roman Empire), factions known respectively as Guelph and Ghibelline, most city-states owing a direct loyalty to one or the other. The result was inevitable conflict between near neighbours. This had already been

PLATE 15
Pietà del Duomo (Florence Cathedral)
c.1547–55
Marble, 92 inches (234cm) high

Although known as the personifications of pity, pietà, the three shown on this and succeeding pages cannot all, strictly speaking, be identified with the group. A pietà is a representation of the Virgin Mary holding the body of the dead Christ (see also plate 1). By this definition, only the Rondanini (plates 16 and 17) is a pietà, the Florentine (below) being a Deposition (removal of Christ's body from the cross) and the Palestrina (plates 18 and 19) an Entombment. Seen as a group created over the last decade or so of Michelangelo's life and in the order listed above, they do however form a poignant and moving statement of Michelangelo's internal struggle as a Christian in search of spiritual reconciliation. The Rondanini, especially, seems to reveal a man desperately in search of an ultimate truth as he pares away at the surface in the hope of reaching a necessary core of faith.

All three show evidence of the work of assistants and the Palestrina has been the subject of dispute by scholars since it first appeared in the 18th century that it was indeed by Michelangelo. It is nevertheless usually included in any catalogue of his work and was itself first recorded in the church of Santa Rosalì, Palestrina. The Rondanini, as it now stands, was a reworking of an earlier pietà and the disembodied arm is a residue of the original, similar in position to that in the Palestrina. The head of Nicodemus in the Florentine Pietà is said by Vasari to be a self-portrait of Michelangelo.

responsible for a number of the dukedoms, since the earlier republics had employed private armies with mercenaries (*condottieri*) to fight for them, some of whom had turned on their employers and had in turn become rulers.

Florence was a Guelph city and it was to this town that Michelangelo was brought when young and in which he grew up, became a loyal citizen and came to regard himself wholly as a son of the city. He was descended from an old respected Florentine family of the Guelph faction and was the second of five sons. His father, Ludovico, was a poor gentleman citizen, although sufficiently well regarded to become a *podesta* (resident magistrate) for a short period of six months in the autumn of 1474, losing office just before Michelangelo's birth. His mother, Francesca de' Neri, of good family, died when Michelangelo was only six. His elder brother, Leonardo, became a Dominican monk with the result that Michelangelo became the senior son and came to be regarded as the eldest. He was given as wet nurse a woman who was the wife of a marble worker of Settignano and Michelangelo later joked that he had imbibed his passion for sculpture with his foster-mother's milk.

Michelangelo decided as a young boy that he would become an artist, despite his father's strong initial opposition, and at the age of 13 was apprenticed for three years as a paid assistant to Domenico Ghirlandaio, then

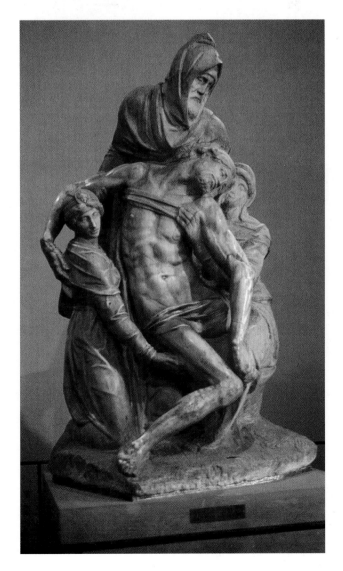

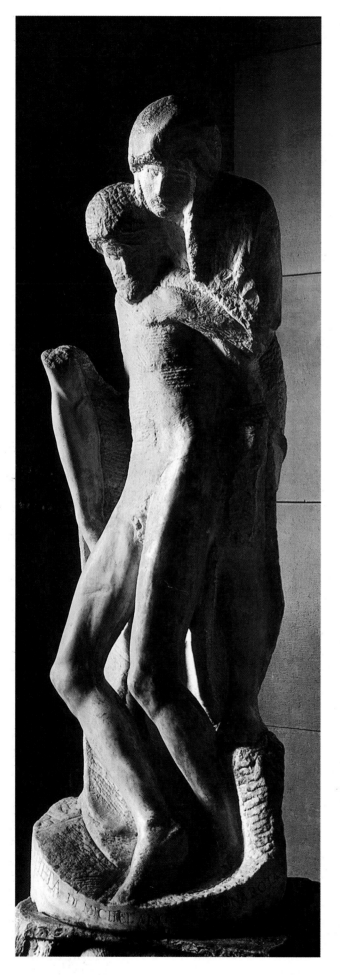

PLATES 16 and 17 detail opposite
Pietà (Rondanini) c. 1550–64
Marble, 77 inches (195cm)

The evidence of the detached oversize arm (seen on the left) suggests that Michelangelo was attempting to rework an earlier group. Vasari, in his biography of Michelangelo, states that he had already started another larger scale pietà *in about 1552–53 (of which the arm and present legs were a part) when he began this work and was still working on it when he died. Despite its unfinished state and the different scale of the parts (the head and upper body are much too small to relate to the limbs) this work has power and the ability to move in its depiction of a mother and her son, a true* pietà, *that goes beyond representation. This is especially revealed in the detail of the heads of the two figures (plate 17 opposite).*

recognized as Florence's foremost painter, a man of great energy and ambition without quite the talent to fully justify his reputation. His grandiloquent offer to paint the entire walls of Florence was, perhaps fortunately, not accepted. Michelangelo did not have the greatest regard for his master and after only about eight months was urged by Ghirlandaio to enrol as a student at the new school of sculpture established by Lorenzo de' Medici who was known as Lorenzo the Magnificent and the most influential citizen of Florence as head of the powerful entrepreneurial Medici dynasty. The school was located in the gardens of the Medici palace near the monastery of San Marco and was conducted by Bertoldo de' Giovanni, a former pupil of Donatello, the great sculptor of the earlier Renaissance. In this way Michelangelo was introduced to his work and came to revere Donatello deeply.

Michelangelo also studied the work of Masaccio, a contemporary of Donatello and one of the important progenitors of the early Renaissance, with Donatello, the architect Brunelleschi and others. Masaccio, a precocious genius who died at the early age of 27, had created his most important paintings in a group of frescoes in the Brancacci chapel of the church of Santa Maria del Carmine in Florence. Masaccio was another influence on the young Michelangelo who spent many hours copying his work with other members of the Medici school.

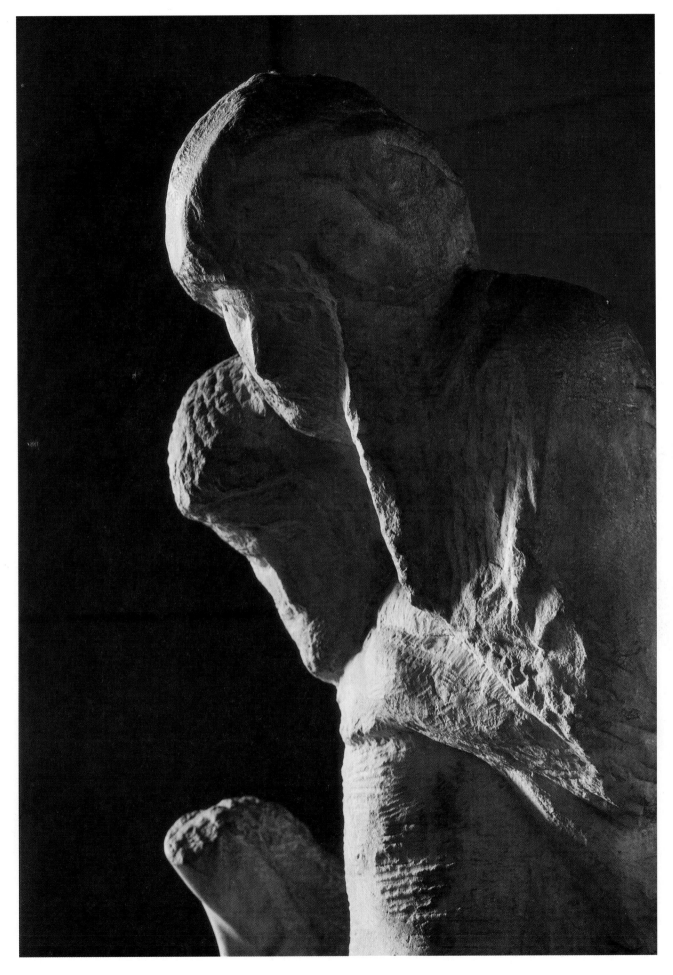

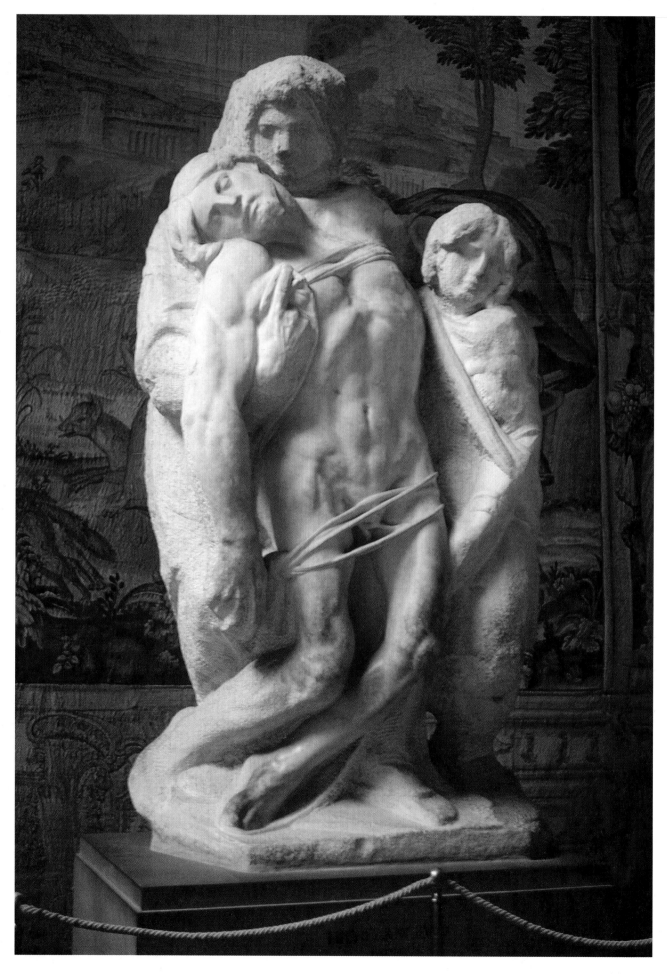

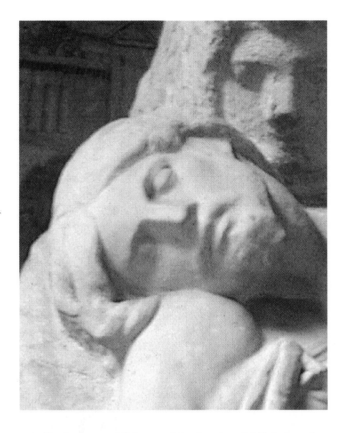

PLATES 18 (opposite) and 19 detail left
Pietà (Palestrina) c. 1556
Marble, 81 inches (206cm) high

Although popularly known as a pietà, this is more properly to be described as an Entombment, as already noted. There has always been some doubt concerning the authenticity of this work since it was first recorded in the 17th century in Santa Rosalì, Palestrina (hence the name). Although related to a number of drawings, it seems certain that some parts of the sculpture were worked on by others. Nevertheless, it remains a powerful image of Michelangelesque character.

During a youthful quarrel in the chapel Michelangelo received a blow which broke his nose, disfiguring him for life. His opponent was Pietro Torrigiano, a fellow student with Bertoldo in the Medici academy, who was later heard to boast: 'I gave him so violent a blow upon the nose with my fist that I felt the bone and cartilage yield under my hand as if they had been made of paste, and the mark I then gave him he will carry to his grave.' Michelangelo did indeed carry the broken nose through life, as portraits of him show, and the fight obliged Torrigiano to flee Florence for the Netherlands, Spain and England, where he completed his most famous work – the tomb of Henry VII. He later met his death in Spain at the hands of the Inquisition.

Although Michelangelo had come into contact with some of the greatest humanist philosophers in the Medici court and had begun to absorb the principles of Platonism and Neo-Platonism, he retained his devotion to his religion and events in Florence in 1490, when he was 15, brought his religious beliefs into sharp focus. Savonarola, a Dominican and prior of San Marco began a series of passionate Lenten sermons in the form of an apocalyptic denunciation of the wickedness and self-indulgence of the people of Florence and the failure of the Church of Rome to maintain sufficient piety and rectitude. He attacked the pope and Florence with ferocious denunciations. The Roman church was furious while the Florentine republic

trembled in fear and tried desperately to mend its ways. Everyone was affected: humanists recanted and the great and wealthy families (Ruccellai, Albizzi and Strozzi) demanded entry to religious orders while the citizens wept and gnashed their teeth. Leonardo, Michelangelo's brother, entered the Dominican order under Savonarola's influence and Michelangelo himself was also directly affected and, after some frightening experiences, fled from Florence to Venice in 1494. In the same year, the two humanists, Pico della Mirandola and Poliziano, both died, requesting that they be buried as Dominicans.

Lorenzo de' Medici died in 1492 and was succeeded by his son Piero, a man of ambition but little attraction, and by 1494 had also fled from Florence against the feared insurrection of the people. A popular government was formed with the support of Savonarola who prohesied the republic would spread across the world. It also became, under the urging of Savonarola, the first and only republic to elect as king, Jesus Christ. The notorious Pope Alexander VI, perhaps better known as Rodrigo Borgia, father of Cesare and Lucrezia, was not pleased and ordered Savonarola to Rome in 1495 to answer a charge of heresy. Savonarola, recognizing the threat and the likely consequences to himself, disregarded the order, was excommunicated and, at the instigation of the pope was with two fellow priests hanged and publicly burnt in the Piazza della Signoria in 1498. For Michelangelo it was a

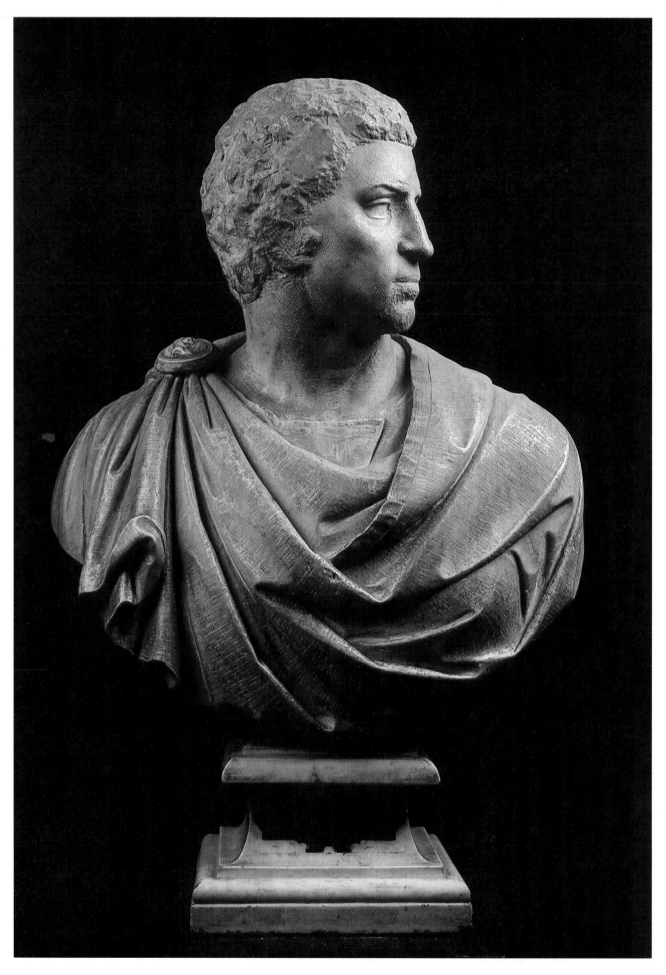

PLATE 20
Brutus (c. 1540)
Marble, 29 inches (74cm) high

The evident inspiration for the form of this sculpture, and for its title, are the familiar Roman portrait busts of emperors, senators and wealthy citizens of Imperial times. As for the title, it has been suggested that this had a political connotation as well, having its parallel in the murder of the much hated Alessandro by Lorenzino de' Medici in 1536 who was much praised as a Brutus figure for ridding the world of a tyrant. Michelangelo's model for the bust was taken from an antique gemstone of what was supposedly the image of Brutus, although research suggests that it was more likely to have been the Emperor Caracalla.

The bust of Brutus was ordered by Michelangelo's friend, Donato Giannotti, publisher of a 'Dialogue' which included a discussion with Michelangelo on the subject of Caesar's assassination and whether or not it could be justified, about which Michelangelo was uncertain. The bust itself, in its unfinished but advanced state, rough-surfaced but effectively modelled, is one of Michelangelo's most powerful images. The clean finish of the drapery contrasts with and emphasizes the rough-hewn grandeur of the strong features of the head. The work has a quality of actuality and implication which identifies a decisive heroic spirit.

powerful impetus to reflect on the state of the church and society and the influence of Savonarola remained a strong component of Michelangelo's Christianity.

After a short stay in Venice, Michelangelo lived in Bologna for about a year as a guest of the Aldrovandi family, where he spent much of his time in studies of the early Italian writers Dante, Boccaccio and Petrarch, becoming a recognized authority on the works of Dante and beginning to write poetry himself. His artistic work was, however, almost completely centred around sculpture. At the end of 1495, Michelangelo returned to Florence and, in the absence of serious commissions, in June of the following year went to Rome for the first time, remaining there until 1501. The most significant work he completed during the stay was the early *Pietà* (plate 1) in St Peter's; commissioned in 1497 it remains the only work signed by Michelangelo.

His return to Florence in 1501, aged 26, marked the beginning of Michelangelo's first great creative period. He was already famous as a Republican, a Christian and a Platonist and was receiving commissions given by the Florentine republic. His large figure of the heroic David (plates 4 and 5), athletic classicism personified, encapsulates Michelangelo's own development at this stage and the well known story of his carving it from a rejected block of marble bears repeating in what it reveals of both the authorities' confidence in his genius and his own unique command of his materials. The great block of marble destined for the giant figure of David had been abandoned 40 years earlier by Agostino di Duccio who had been in the process of carving what is also believed to have been a figure of David. Since that time, the cathedral authorities who owned the block had been looking for a sculptor capable of working it. In September 1501 they settled on Michelangelo who, by April 1504, succeeded in completing the great figure. Not only was his ingenuity admired, but the figure was received with enormous acclaim, so much so that it became a symbol of Florence itself. Earlier versions of David by Verrocchio and Donatello had envisaged him as a victorious, if callow, youth. Michelangelo's figure is of a virile figure of Herculean proportions, gazing fearlessly towards his foe, a lithe modern classical nude.

Nevertheless, it was Leonardo da Vinci, 23 years Michelangelo's senior, who was the great figure in Florentine art at that moment. Michelangelo was aware of this and studies he made at the time reflect Leonardo's influence – and Michelangelo's rivalry. His cartoon for the Battle of Cascina was a reflection of that competition in that Leonardo was also working on cartoons for the Council Hall of the Palazzo Vecchio for which he had been commissioned to provide decorations depicting Florentine victories. Leonardo was painting a mural of the Battle of Anghiari, a Florentine victory over the Milanese. Michelangelo's cartoon showed a moment in the battle with the Pisans.

Michelangelo was obliged to stop work on the cartoon when he was called to Rome in 1505 by Pope Julius II who wished him to execute a funerary monument for him, to be completed during his lifetime.

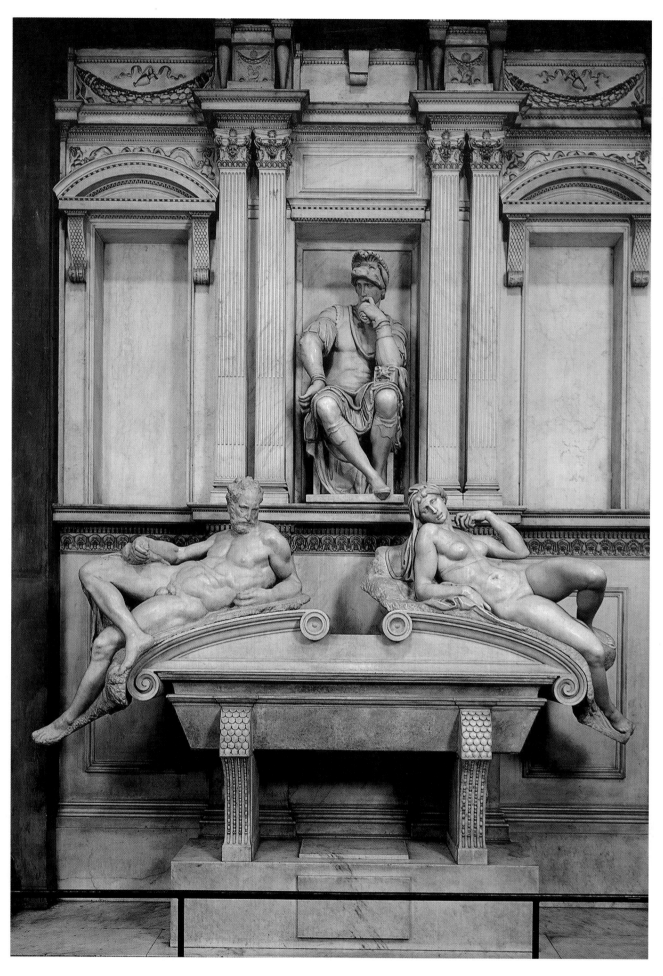

The Medici Chapel, Church of San Lorenzo, Florence (1520–34)

PLATE 21 *(opposite) Tomb of Lorenzo de' Medici with supporting figures of Twilight and Dawn.* PLATE 22 *(below) Tomb of Giuliano de' Medici with supporting figures of Night and Day. (All figures in marble.)* PLATE 23 *(overleaf left) Drawing of tomb for Lorenzo.* PLATE 24 *(pages 32–33) Interior view of chapel from altar to show architectural details by Michelangelo on lower level.*

San Lorenzo became the burial place of the Medici family. There were already five tombs in the church, two of them in the old Sacristy by Brunelleschi. (Brunelleschi was the architect of the Cathedral dome and lantern and the architect of the Medici chapel of which Michelangelo assumed control while it was still under construction to his design.) It is not precisely known what each contributed to the present structure, but Brunelleschi was certainly responsible for its basic symmetrical shape. Cardinal Giulio de' Medici probably commissioned Michelangelo to design the tombs for Lorenzo the Magnificent, Giuliano his brother (murdered in the Pazzi plot in 1478), Lorenzo, Duke of

Urbino and the Magnificent's grandson, and Giuliano, Duke of Nemours and the Magnificent's third son. Only the tombs of the dukes were completed and this has given rise to the misunderstanding (because of the repetition of the two names) that the tombs are those of the Magnificent and his brother.

Papal succession had a great deal of effect on the progress of this project. At the time of its inception, Pope Leo X (Giovanni de' Medici) was on the papal throne; but he died in 1521 and it was not until Giulio de' Medici became Pope Clement VII that the project pressed forward. As the programme developed, Michelangelo's ideas – as they were wont to do – enlarged, and the intended work plans became larger than were practicable, resulting in the partial completion which lays major emphasis on the figures of the two capitani *instead of, as was intended, on the tomb of Lorenzo the Magnificent. This was intended to be on the wall facing the two completed sculptures and has resulted in an unbalanced design which clearly looks unfinished. What is there, nevertheless, comprises some of Michelangelo's most important sculpture and represents a vision the loss of which, in its projected totality, is very great.*

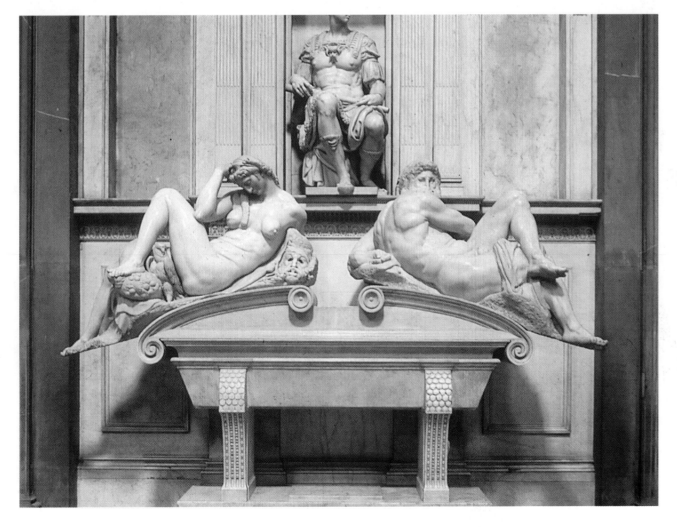

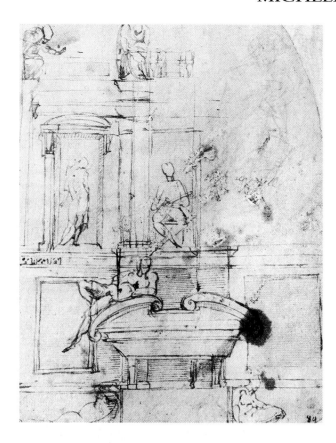

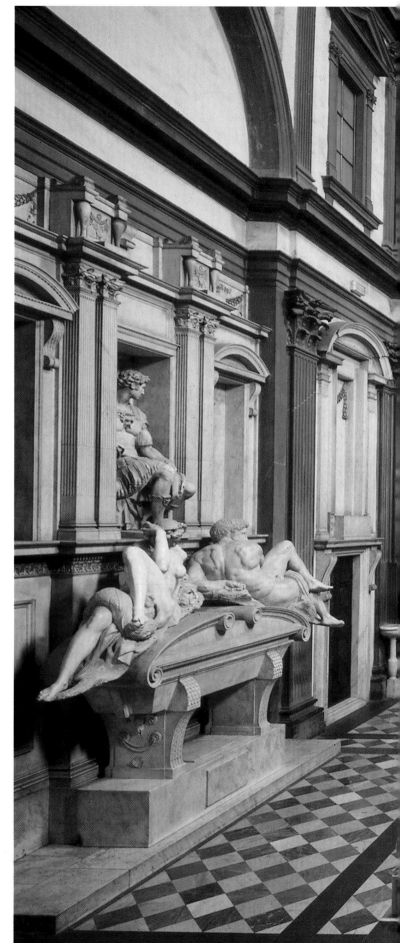

There was a strong, if confrontational affinity between Julius and Michelangelo and Julius certainly admired Michelangelo's smouldering, passionate temperament – what has been termed his *terribilità*. Michelangelo was enthusiastic to be working on an important sculptural project and energetically began work on the design sketches from which one was chosen and was despatched to Carrara to select the marble. After his return to Rome he waited impatiently in his studio workshop near St. Peter's, but by this time the pope had changed his mind, requiring instead that Michelangelo should decorate the ceiling of the Sistine Chapel (plates 45 et seq.), in the Vatican. Michelangelo, who always saw himself primarily and essentially as a sculptor, wished to continue with the mausoleum but when he asked for money in order to proceed with the project was refused access to the pope and, deeply offended, fled to Florence in August 1506.

Pope Julius II, one of the great figures of the Renaissance, was a humanist, warrior and art-lover, determined to throw lavish resources into great artistic and architectural projects. When he asked Michelangelo to paint the Sistine ceiling he had, at the same time, also asked Bramante to prepare new designs for the rebuilding of St. Peter's. Bramante was an important architect and the first stone in the new basilica was laid the day after

continued on page 38

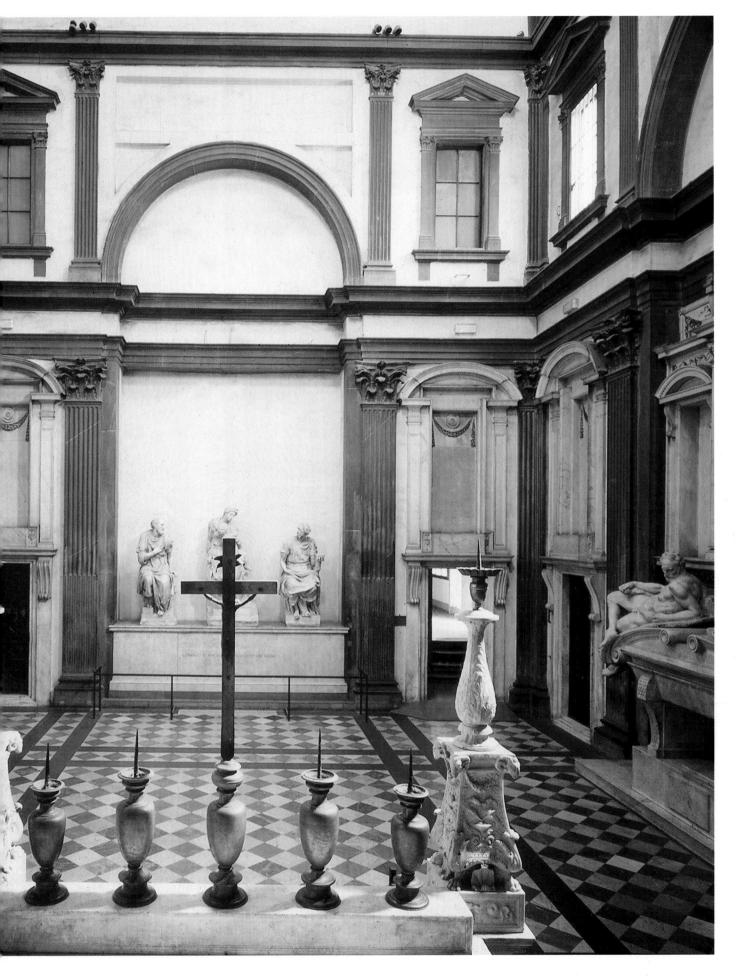

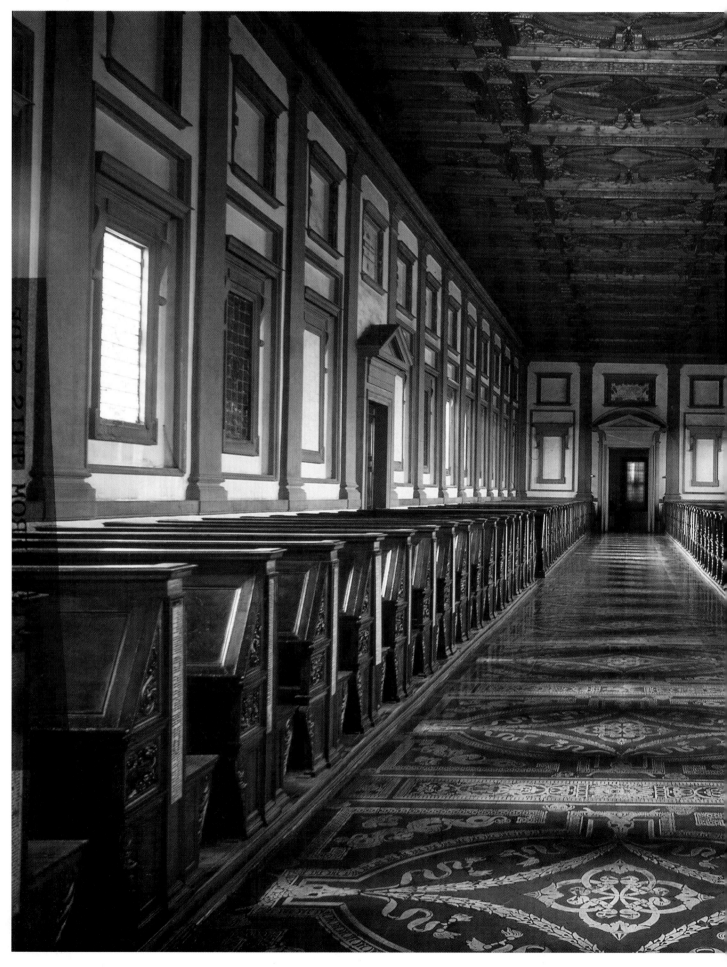

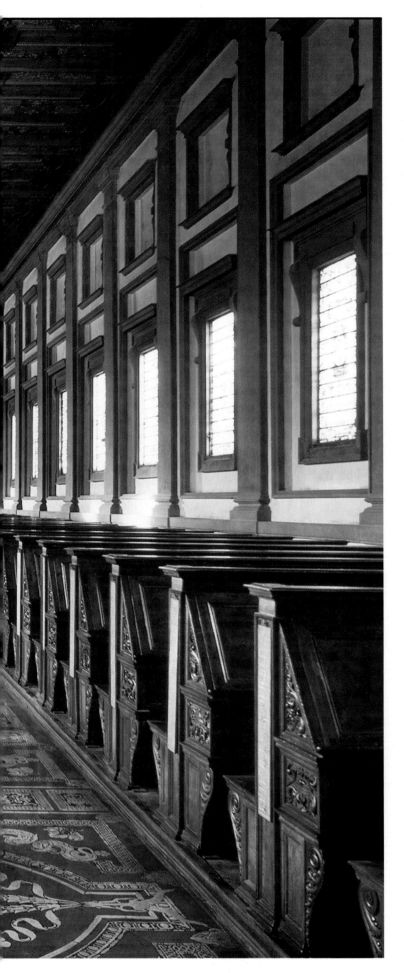

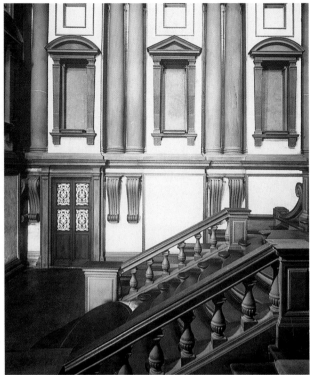

PLATE 25 above
**Vestibule of the Laurentian Library
(**1524-34)

PLATE 26 left
**View along the reading-room of the
Laurentian Library** (1524–34)

*The Medici Pope Clement VII commissioned Michelangelo in
1524 to prepare plans for a new library within the cloisters of
San Lorenzo to house the books and manuscripts belonging to the
family. Although the work began in 1524, it was suspended two
years later, resumed in 1530 and again suspended in 1534. It
was left in this state until 1550 when the direction of the project
was taken over by the architect Bartolomeo Ammanati.
Michelangelo had no further part in the building but it was
completed to his design after his death. Michelangelo had
conceived the vestibule, rising eventually to three storeys, as a
preludium, designed to transport the scholars from the mundane
outer world to the peace of the scholarly life within the library.
The tall vestibule contains a triple staircase which rises to the
reading room, giving a visual introduction as indicated in the
illustration above. It was a bold and original design and its
treatment of the architectural elements presages the mannerism
soon to replace the classical restraint of the High Renaissance.*

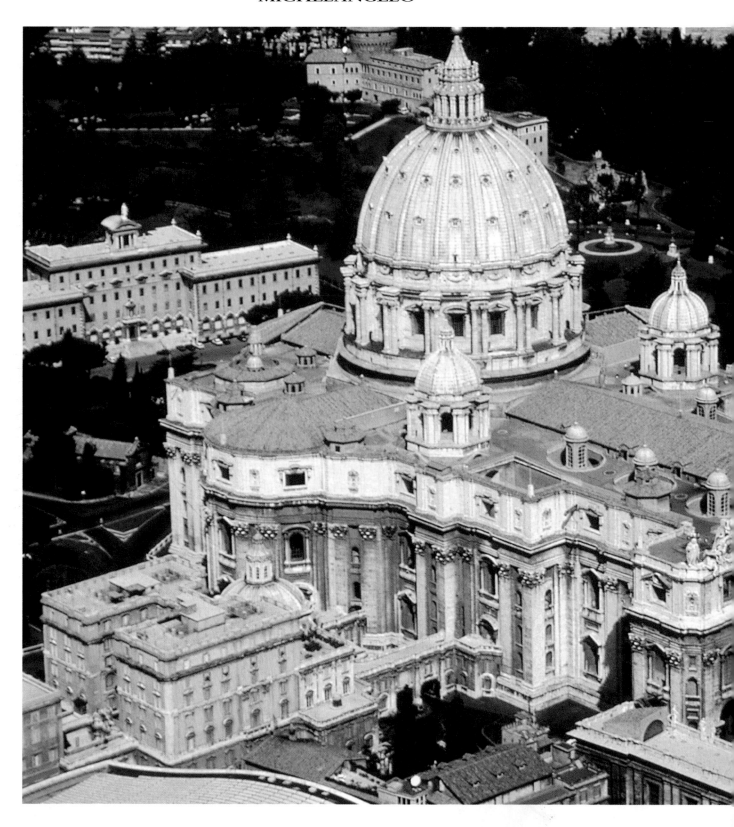

PLATE 27
The Cathedral Church of St. Peter, Rome
(1506–mid 17th century) aerial view

Although the rebuilding of the great basilica of St. Peter began under the papacy of Julius II (who commissioned Bramante to create a replacement work) it proceeded very slowly until

Michelangelo was appointed architect by Pope Paul III in 1546 and he laboured on the project for the next 18 years until he died in 1564. He modified Bramante's plan and made a design for the magnificent dome which was completed after his death. His intention of providing a centrally planned church was frustrated by the addition of a nave, atrium and façade by Carlo Maderno in the early 17th century. The only feature clearly to be seen that is

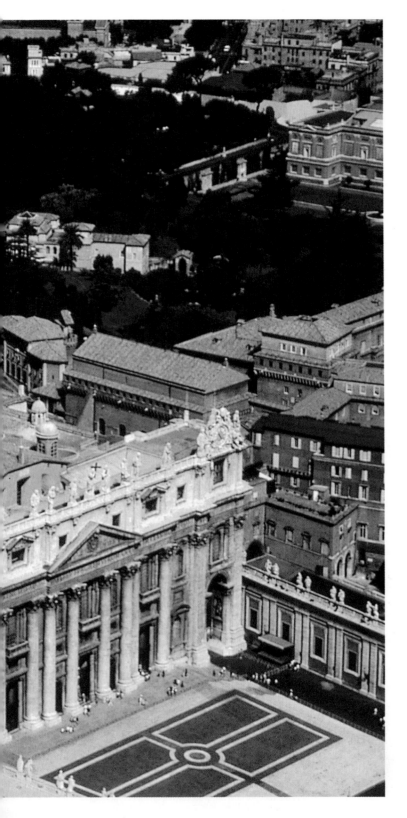

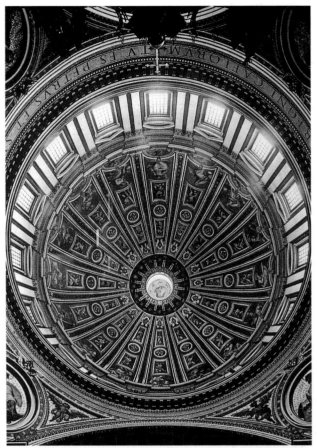

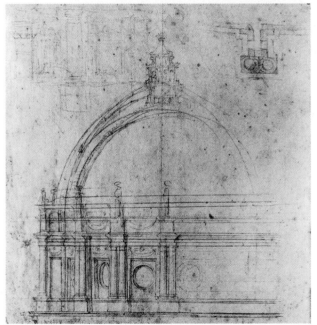

by Michelangelo is the dome. The decoration of the interior of the dome (plate 28) was added in the 1590s on the direction of Pope Clement VIII. The diameter of the interior is 138ft (42m). As can be seen from one of Michelangelo's original sketches (plate 29), his intention was somewhat elaborated in the final form.

PLATE 28 top
Interior of St. Peter's Dome

PLATE 29 above
St. Peter's Dome
Drawing by Michelangelo

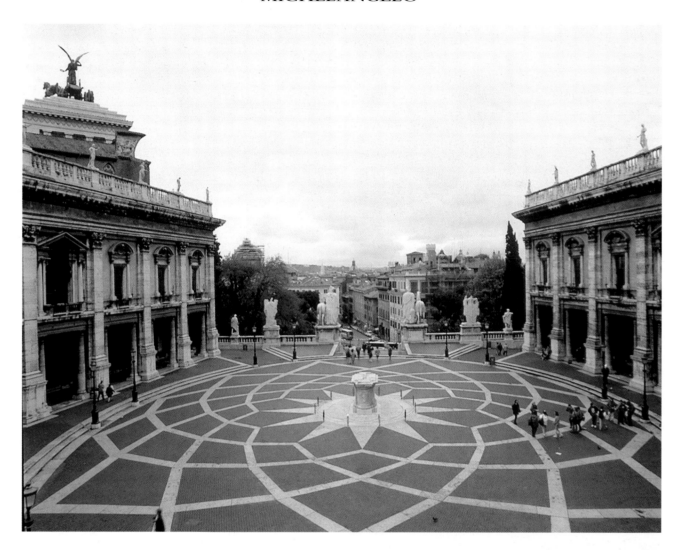

continued from page 32

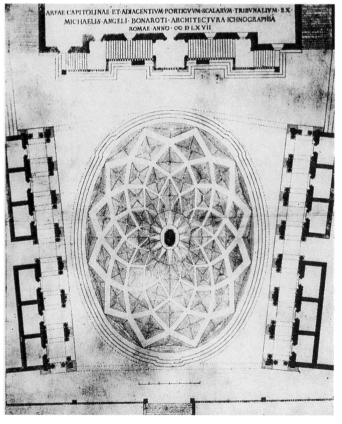

Michelangelo left Rome. Michelangelo was no friend of Bramante's and believed him to be the instigator of the Pope's request that he should paint the Sistine: this was the initial cause of the bad blood which existed between the two and the events which subsequently occurred.

Michelangelo had not finished with the Julian tomb project and to some degree it occupied his mind for the next 40 years, during which he produced at least six different design schemes. He believed he had a legal obligation to complete the work and it was a constant worry that he was unable to proceed with a task that was greatly attractive to him. In early 1508, Michelangelo was again in Rome where the subject of the Sistine Chapel ceiling was again broached by Julius II. Reluctantly, he accepted the commission which, when completed, turned out to be one of the most awe-inspiring examples of Michelangelo's creative genius, as well as the most physically taxing, demanding all his powers and seemingly limitless determination. It is certainly an almost

continued on page 45

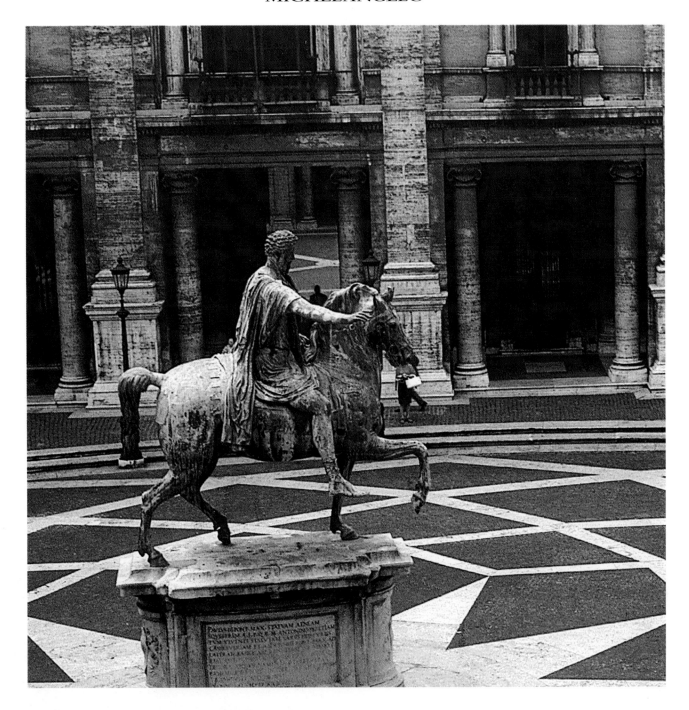

PLATES 30 (opposite above), 31 (opposite below),
32 above

Piazza del Campidoglio, Rome

*The commission given to Michelangelo by Pope Paul III to
redesign the Capitol, historically the central and most important
civic centre of classical Rome, was one of the greatest significance.
Its spirit was alive in the minds and the hearts of the Renaissance
citizens despite its undistinguished architectural character.
Michelangelo was influenced by this and saw the importance of
the site. His first design element was to place the classical
equestrian statue of Marcus Aurelius (plate 32) on an elevated
ellipitical base. This determined the character of the whole design*

*which took the form of a large oval piazza bounded by three great
palaces, the Palazzo Senatorio, the Palazzo del Museo
Capitolino and the Palazzo dei Conservatori, placed to form a
narrowing boundary looking towards Rome as illustrated in plate
30 (opposite above). The patterned pavement was also to
Michelangelo's design. The work was not completed in his
lifetime, but to his basic intention later. Michelangelo's intention
is perhaps best revealed by the plan of the Piazza (plate 31
opposite below) which expresses both the contained importance of
the site and focuses on the Palazzo del Senatore, fronted by the
reminder of the significance of Rome's history, the figure of the
Emperor Marcus Aurelius.*

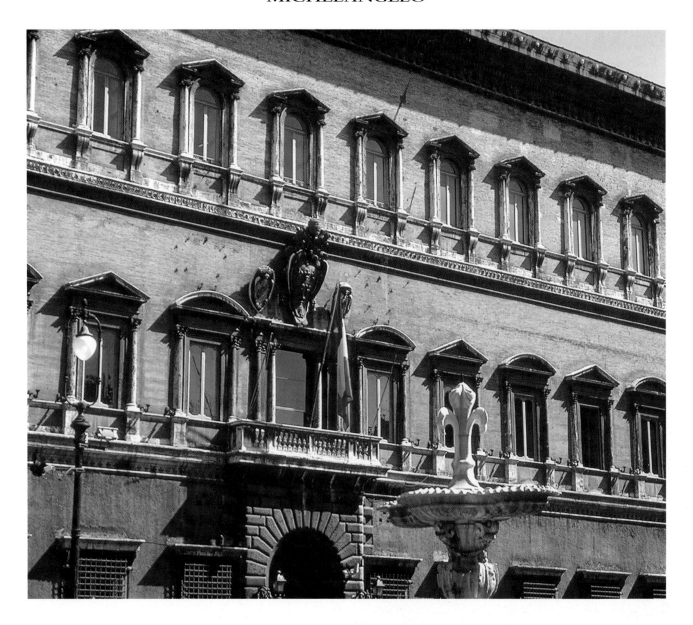

PLATES 33 (opposite) and 34 above
Façade of the Farnese Palace, Rome
(designed by Antonio da Sangallo the Younger)
1517-1546

Additions made by Michelangelo after 1546 include the great window over the portal illustrated above. Its four green marble columns support the Farnese arms. Michelangelo also added the great cornice and the piano nobile *upper story of the courtyard.*

PLATE 35 right
Drawing for design of the Sforza Chapel in Santa Maria Maggiore, Rome (1546-1549)

Michelangelo's last architectural work was actually carried through by his pupil Tiberio Caleagni but without the individuality which was the essence of Michelangelo's architecture and which brought him criticism as not being sufficiently 'Vitruvian'.

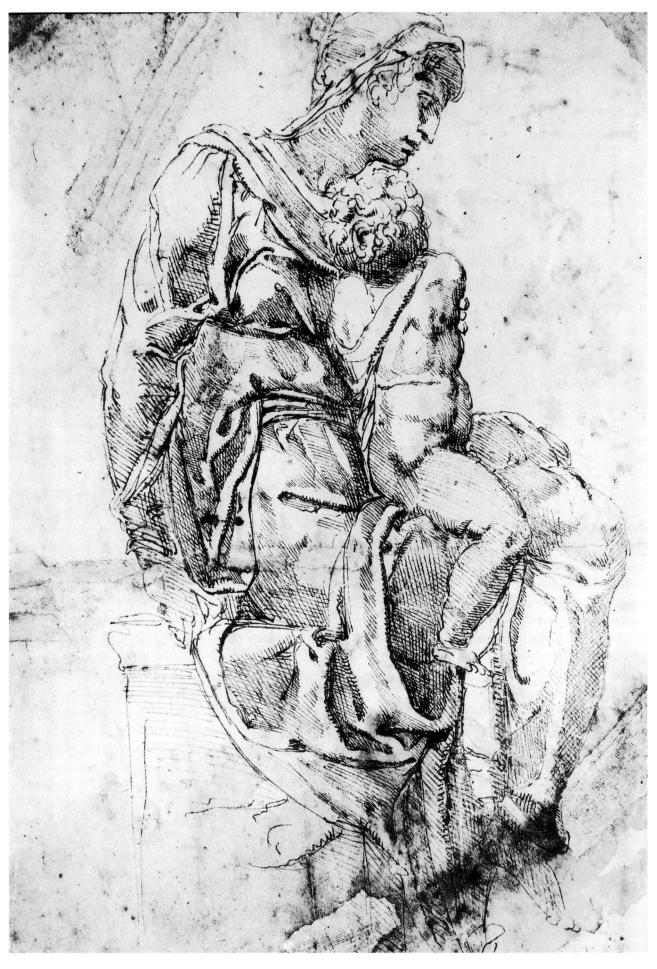

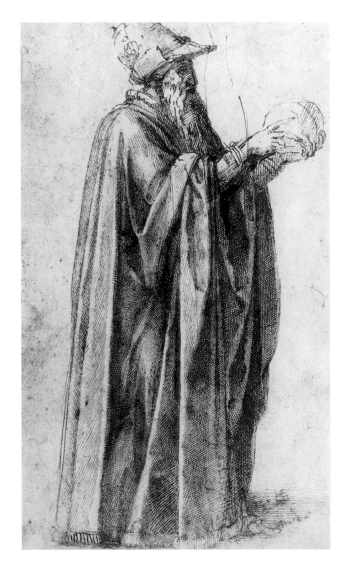

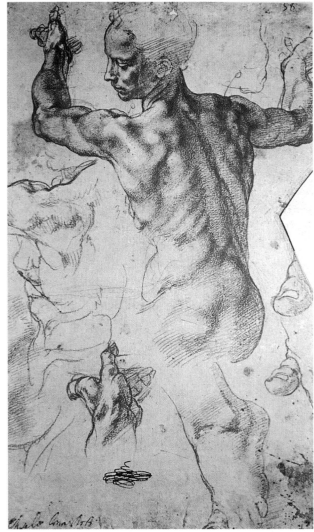

PLATE 36 opposite
Virgin and Child
Pen and ink drawing on paper

The Virgin and Child is a largely linear drawing undertaken to examine the possibilities of light and shade within defined form, while in the so-called Alchemist (plate 37) there is a statuesque treatment worked to a more careful finish. The title Alchemist (as suggested by Tolnay) is only one of a number offered – others include 'Sage' and 'Astrologer' – based on whether he is carrying a sphere or a skull. It appears to be a young man's work.

With the third drawing (plate 38), there is a clear inspiration in that it is an anatomical study for the Libyan Sibyl on the Sistine ceiling. It has been suggested that the second hand and head are the work of another person.

PLATE 37 above left
The Alchemist (c. 1500)
Pen and pencil, 13 x 8$^{1}/_{3}$ inches (32.8 x 21.1cm)

PLATE 38 above right
Study of the Libyan Sibyl for the Sistine Chapel ceiling (c. 1511) see also PLATE 54
Sanguine, 11$^{1}/_{2}$ x 8$^{1}/_{2}$ inches (29 x 21.5cm)

The brilliance of Michelangelo's draughtsmanship and his intellectual power is seen at its most immediate intensity in his sketches and studies for his major works in painting and sculpture. He also left a number of most intriguing architectural designs in the forms of drawings. A number of drawings from the large number which have survived have therefore been included to indicate the range of this important aspect of his work.

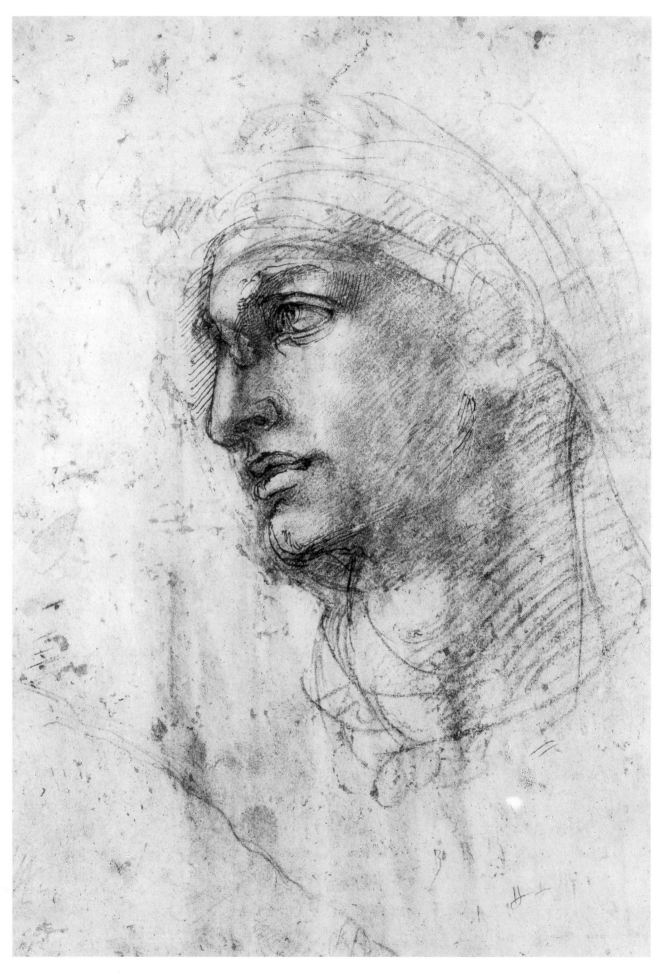

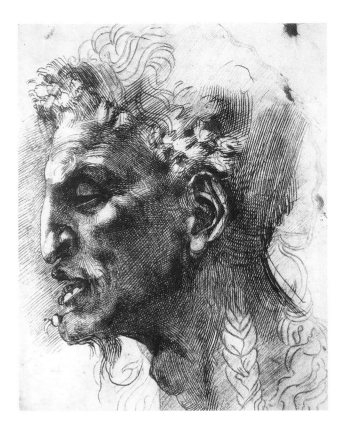

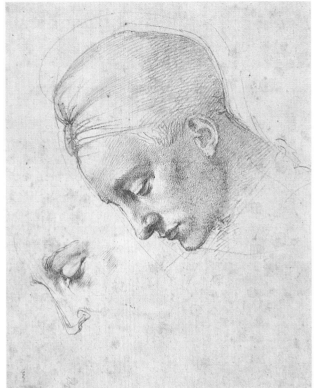

PLATE 39 opposite

Head of Adam

Sketch

PLATE 40 above

Head of a satyr

Pen and ink

PLATE 41 above right

Study of head

Sanguine

These three studies vividly show the various qualities and techniques of Michelangelo's draughtsmanship. The sketch of Adam (plate 39) is exquisitely sensitive when compared to the drawing of the satyr above. A rough outline has been drawn and the remainder of Adam's head has been sensitively sketched in to show form as well as light and shade. One feels that the character of the subject is revealed in the drawing.

The satyr (plate 40), executed with boldness and immediacy, leaves little room for any margin of error, the cross-hatching being an important feature of Michelangelo's technique.

The study of the head (plate 41) is in complete contrast to the other two. It is an accurate and serious study to show a likeness, the beautiful and subtle rendering being nearer in spirit to the drawings of Leonardo da Vinci.

continued from page 38

superhuman achievement and no other painting project, however vast in area, carries such deeply demanding spiritual messages and powerful imagery. Charles de Tolnay, the recognized authority on Michelangelo, describes the ceiling as the 'masterwork of Michelangelo's early maturity'.

The ceiling occupied four years of Michelangelo's life and left him physically exhausted. It is said that he had spent so much of the time looking upward that for some time after the work was finished he could only read by holding up pages above his head. The work was unveiled on the last day of October 1512, when it was acclaimed and revered. Michelangelo then turned to what was closest to his heart, sculpture, and to the subject that had troubled him during the whole of the last four years, the tomb of Julius II; but it appeared that Julius was not anxious that he should continue. When Julius died suddenly of a fever in February 1513, his executors drew up a new contract for a reduced project, extending the time allowed from five to seven years and raising the price. Michelangelo, with renewed energy and enthusiasm worked on three figures for over two years (two slave figures and the central figure of Moses), the most important work completed for the tomb. (See plates 9–10 and 12–13.)

Julius II was succeeded by Leo X (Giovanni de' Medici, second son of Lorenzo the Magnificent) who had

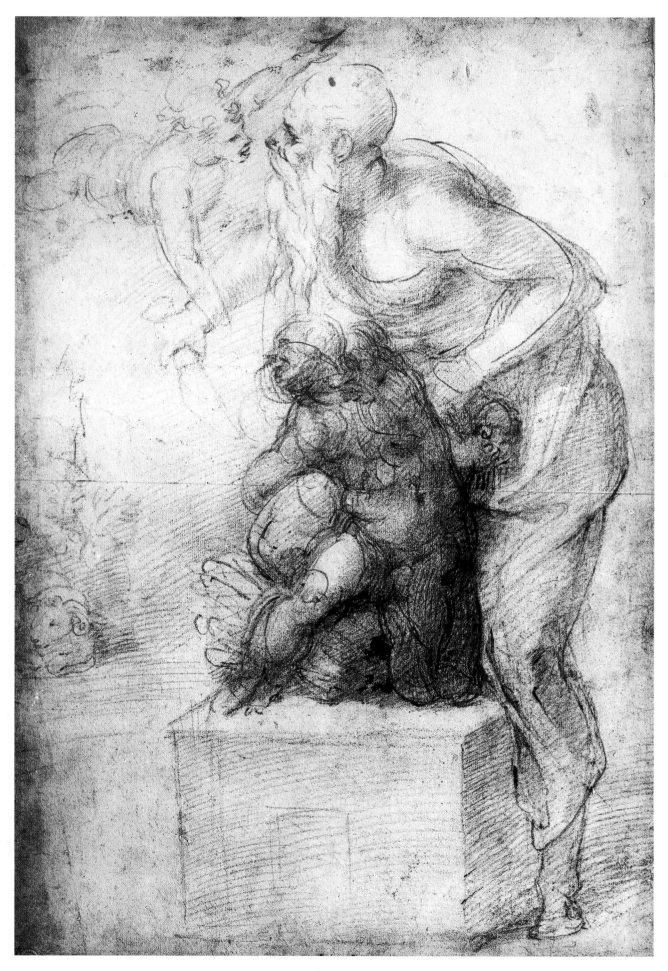

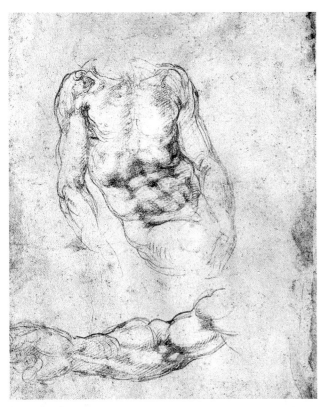

PLATE 42 opposite
Study for the Sacrifice of Isaac by Abraham
(1532–33)
Black pencil, ink and sanguine, 16 x 11¹/₃ inches
(40.8 x 28.9cm)

PLATE 43 left
Anatomical study
Black pencil, 10¹/₈ x 6¹/₈ inches (25.8 x 15.7cm)

PLATE 44 below left
Anatomical study: a man kneeling, back facing (c. 1530)
Black pencil, 10¹/₈ x 7 inches (25.8 x 17.7cm)

One authority has suggested that this is a study for one of the figures of the damned for the Last Judgement *(plates 60–62).*

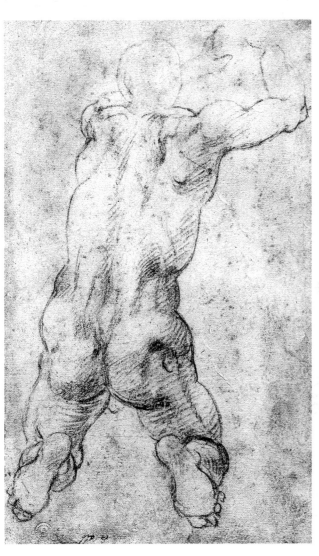

been a cardinal since the age of 16 and, as a result of conflict between the houses of Della Rovere and the Medici, the contract for the tomb was again reduced and another new contract was signed in 1516. Not much creative work was done during the succeeding three years as Michelangelo spent most of the time in the Carrara quarries selecting the stone for one of his first architectural commissions, the façade of San Lorenzo, Florence. On 10 March 1520, the pope annulled this contract which Michelangelo, unused to being thwarted, took as a *vituperio grandissimo* (very great insult). But the Medici pope had other work for him to do and in the same year Michelangelo signed a new, even more acceptable contract for the design of the interior of the burial chapel of the Medici in San Lorenzo (plate 24), a classical church designed by Brunelleschi and constructed in the early 15th century. (There is still discussion among scholars as to the contribution of each to the existing chapel.) This Florentine contract naturally precluded further work on the Julian tomb, the contract for which was still valid.

Michelangelo was in Florence working on the Medici chapel when, in 1522, the situation again changed. The Della Rovere family were returned to power in the person of Adrian VI who, during his short pontificate, supported a demand that Michelangelo complete the tomb according to the contract or pay back all the money received. However, Adrian shortly died and was succeeded by

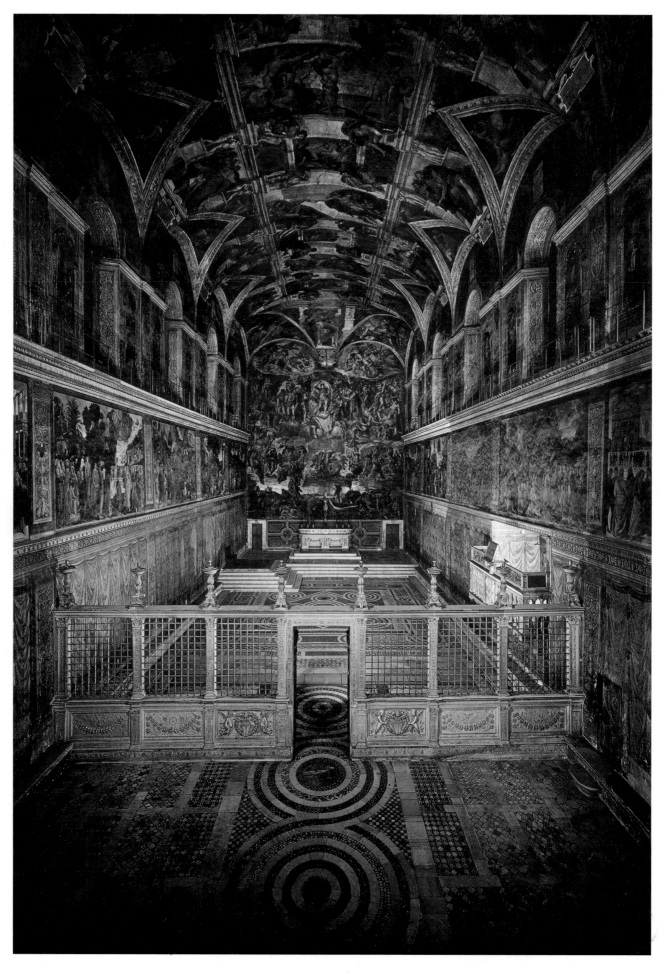

PLATE 45 opposite
The Sistine Chapel (1508–12)

Michelangelo's major painting is to be found in the ceiling and end wall over the altar in the Sistine Chapel of the Vatican, Rome. A few other paintings and a quantity of drawings complete his surface two-dimensional work. Despite this apparently small oeuvre, Michelangelo's contribution to painting is recognized as a glory of Renaissance art. The ceiling of the Sistine is in its scale, conception and execution the greatest single painting of the Renaissance. The Last Judgement (plates 60–62), even with the unfortunate additions, is one of the most moving expressions of undaunted faith in a doubting humanist world.

It is, however, advisable to bear in mind that Michelangelo always regarded himself first and foremost as a sculptor and a sculptor's vision is evident in all his paintings. Sculpture is the identification of physical form in finite volume and in almost all the figures he painted, the volumetric quality is omnipresent while the location is simply and basically indicated. The human figure has been the traditional sculptural thematic concentration and this is evident in Michelangelo's treatment of landscape; historically, the human figure in sculpture, in groups or singly, is created in isolation, any additions being present for structural support. One must look therefore to the power of Michelangelo's figures in his sculptures and he shows the same power, strength and intellectual intensity in his paintings. Indeed, because of the more effective transmission of pictorial imagery, his painting is even better known than his sculpture and the Sistine Chapel is one of the most revered endeavours of Western art.

The Sistine Chapel was named after its builder, Pope Sixtus IV, who had it designed by a Florentine architect, in 1473. It is a simple long rectangular chamber with a coved ceiling originally painted with gold stars on a blue ground. In 1506, the year in which the foundation stone for the new church of St. Peter's was laid by Pope Julius II, for a design by Donato Bramante, the energetic and indefatigable pope also conceived the idea of replacing the star design with a great painting. In 1508, Michelangelo was contracted to make a painting containing representations of the twelve apostles.

Michelangelo was initially unhappy with his first drawings but the pope, as Michelangelo wrote in a letter, ' ...gave me a new commission to make what I wanted, whatever would please me.' It was a commission, accepted with reluctance, which took four years and, unlike most of his large sculptural works, was completed.

For many obvious reasons, the effective study of a single painting that is 133 feet long and 43 feet wide (41 x 13m) on a coved ceiling 85 feet (26m) above ground is only possible by visiting the actual work; but since it is broken into a number of panels in a painted architectural structure and with a supporting series of individual figures, it is possible to take some pleasure in examining its details, while trying to imagine them in the context of the whole. It follows that it is also necessary to look at the images in a book in this way.

Michelangelo's physical working conditions should be remembered. A scaffolding, constructed in two stages, nearly 80 feet (24m) in height necessitated carrying all materials up ladders or hoisting them through pulleys. The ceiling is painted in fresco, a method with demanding technical preparation of layers of plaster onto which the image has initially to be painted when the surface is wet. Since plaster dries overnight, it is essential to complete the area to be plastered in one day and to be able to add to it the next day's work without joins being visible or colours not registering. Linking the scale of a painting 41 metres long is obviously extraordinarily difficult, especially when the painter is up close to his subject (which will be viewed from nearly 24 metres' distance), and is painting directly over his head which necessitates constantly looking upward. All this seems difficult enough and physically very taxing, but Michelangelo had more to contend with. Firstly, he had an authoritarian master/client in Pope Julius II, who was so interested in the proceedings that he or his staff constantly interrupted Michelangelo's work. Secondly, after he had completed nearly a third of the ceiling, the plaster failed, necessitating its removal and a fresh start. It was Michelangelo's belief that the then architect of the Vatican who was responsible for the whole project, his rival Donato Bramante, had deliberately supplied inferior plaster. Although it is unlikely to have been true, the thought preyed on Michelangelo's mind and did nothing to improve his disposition.

The ceiling is divided into major sections using painted architectural elements. There are nine history paintings: The Drunkenness of Noah, The Deluge, The Sacrifice of Noah, The Fall of Man, The Creation of Eve, The Creation of Adam, God Dividing the Earth from the Waters, The Creation of the Sun, Moon and Planets, God Separating the Light from the Darkness.

Twelve prophets and sibyls are arranged around the nine history panels: Zacharia, Joel and the Delphic Sibyl, The Erythrean Sibyl and Isaiah, Ezekiel and the Cumaean Sibyl, The Persian Sibyl and Daniel, Jeremiah and the Libyan Sibyl, Jonah. (See plates 47–59.)

Other scenes are depicted in the spandrels and a number of nude male figures (ignudi) appear on supporting painted pedestals around the history panels.

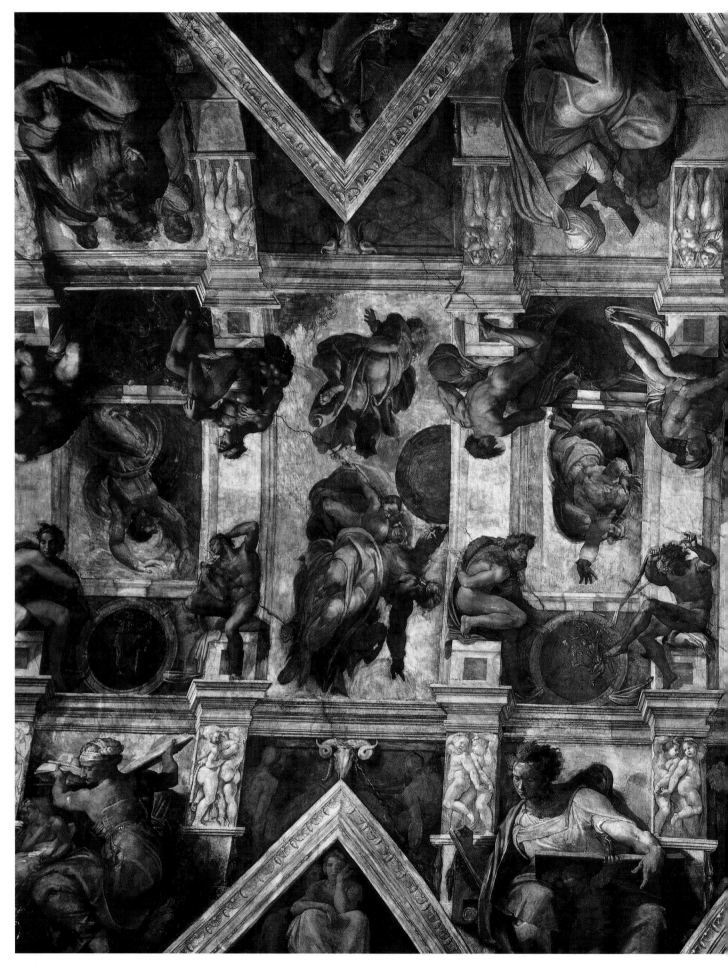

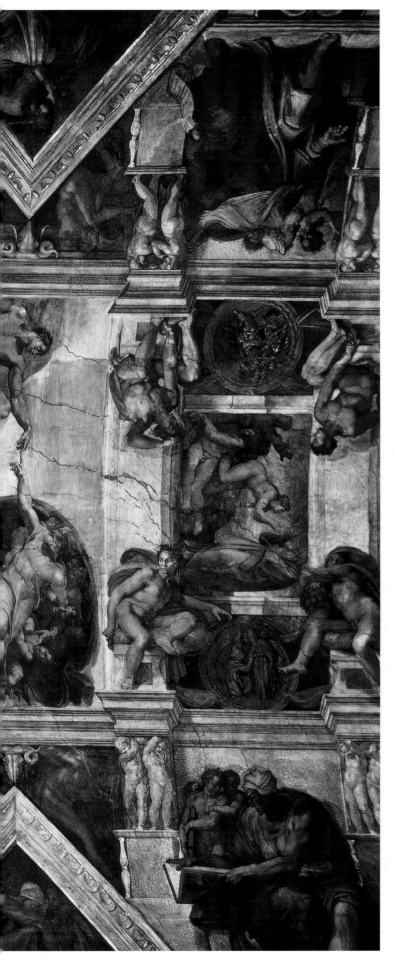

PLATE 46
Sistine Chapel vault (large central detail)

The disposition of the ceiling paintings reads chronologically from the altar and Last Judgement *fresco rather than, as might be anticipated, from the entrance end. The section illustrated here, reading from the left, includes the panels* God Separating the Light from the Darkness, The Creation of the Sun, Moon and Planets, God Dividing the Earth from the Waters, The Creation of Adam, The Creation of Eve.

Clement VII (Giulio de' Medici), the illegitimate son of Giuliano de' Medici, brother of Lorenzo the Magnificent, and cousin of Leo X. With the return of the Medici, all threats of lawsuits were thereby removed and Michelangelo was again required to return to Florence to work on the Medici chapel.

In 1527, the larger European political scene was dominated by the conflict, partly over possession of Italy, between the Holy Roman Emperor, Charles V, and Francis I of France, which in Italy resulted in the Sack of Rome and the incarceration of the pope, Clement VII, who had sided with Francis I. Florence had meanwhile seized the opportunity that this provided to expel the Medici and set up a new republic. Clement, in a typical Renaissance *volte face*, became reconciled with Charles V and was determined to return Florence to Medici domination with the assistance of Imperial forces. The city resisted and Michelangelo was made responsible, as engineer-in-chief, for the fortifications of the city. Clement was an indecisive figure, not highly regarded or respected in the city but, even so, Michelangelo recognized the hopelessness of the Florentine republican cause both through internal treachery and the overwhelming superiority of the Imperial forces ranged against the city; he returned to Venice, where he had earlier been on a diplomatic mission. After the defeat of the city and the harsh retribution initiated by Clement, Michelangelo returned to Florence and was pardoned by Clement – a magnanimous gesture in those retributive times – and tried to extricate himself from the Julian tomb contract; but a new one was drawn up in 1532, the scale of the scheme being reduced yet again. It was also decided to erect the tomb in the church of San Pietro in Vincoli, Rome and not St. Peter's as had earlier been planned.

During the 12 years between the accession of Clement VII in 1523 and the year 1534 when he went to Rome,

PLATE 47
The Creation of Adam (Man)

This is perhaps the most familiar and admired image in this superhuman work. It presents one of the most powerful imaginative images of the Deity in the whole of art and one feels that the electrifying life force that leaps from the outstretched finger of God, enlivening the languid body of Adam, identifies in one image the whole creative process. The sweeping form of the Deity and entourage is beginning to be reflected in the curve of Adam's body as God creates Humanity.

Michelangelo worked on the designs for the Medici chapel. First it was proposed that he should associate with another artist, Sansovino, in the work; but Michelangelo was so outraged that the proposal was dropped and Clement offered a palliative in the form of a contract for a new Medici library, the Biblioteca Laurenziana (plates 25–26). This resulted in one of Michelangelo's most remarkable architectural designs and one of considerable invention; but his principal programme was the completion of the Sagrestia Nuova (New Sacristy), the sepulchral chapel in San Lorenzo. The original intention had been to include memorials to the great founders of the Medici dynasty, Cosimo I (*pater patriae*) and Lorenzo the Magnificent, his grandson. In the event, the sculptures are of two minor Medici, Giuliano, Duke of Nemours and Lorenzo, Duke of Urbino, names which have given rise to a common misunderstanding that the sculptures are of Lorenzo the Magnificent (although it was originally intended that he should be included) and his brother Giuliano, killed in the Pazzi conspiracy of 1478. Michelangelo provided both the portrait figure sculptures and the supporting allegorical nudes of Twilight and Dawn and Night and Day (plates 21 and 22). He was responsible not only for the sculptures, which included a Madonna and Child, but also for the architectural modification of the Brunelleschi structure itself. There is still some doubt as to the extent of Michelangelo's contribution, but the interior certainly reflects his architectural philosophy.

In 1534, Michelangelo returned to Rome where he stayed for the 30 years of life remaining to him. Already a master of enormous reputation and achievement, great works were still to come. He had hoped to complete the tomb of Julius in accordance with the new contract of 1532 when he arrived in Rome, but Clement had other ideas. He had already raised the question of a repainting of

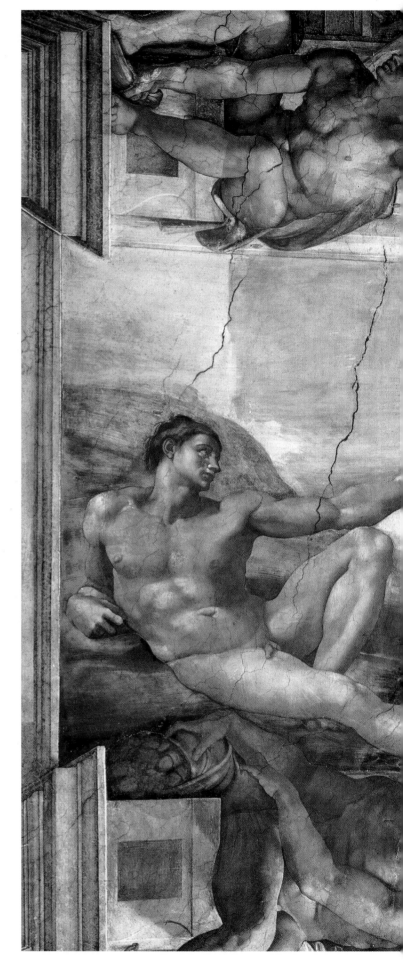

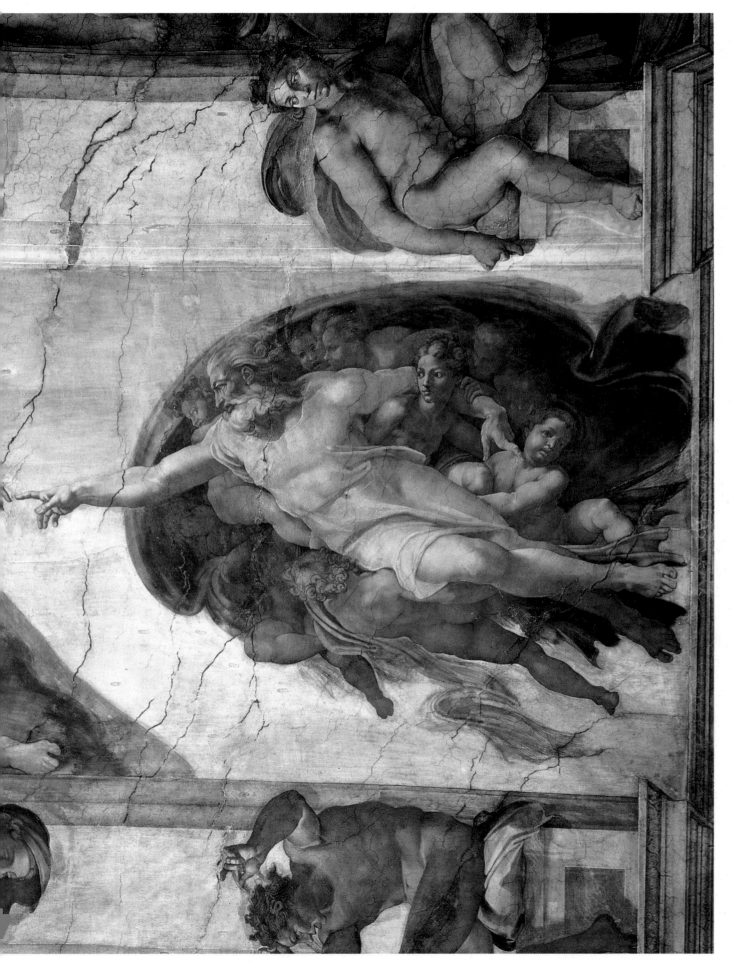

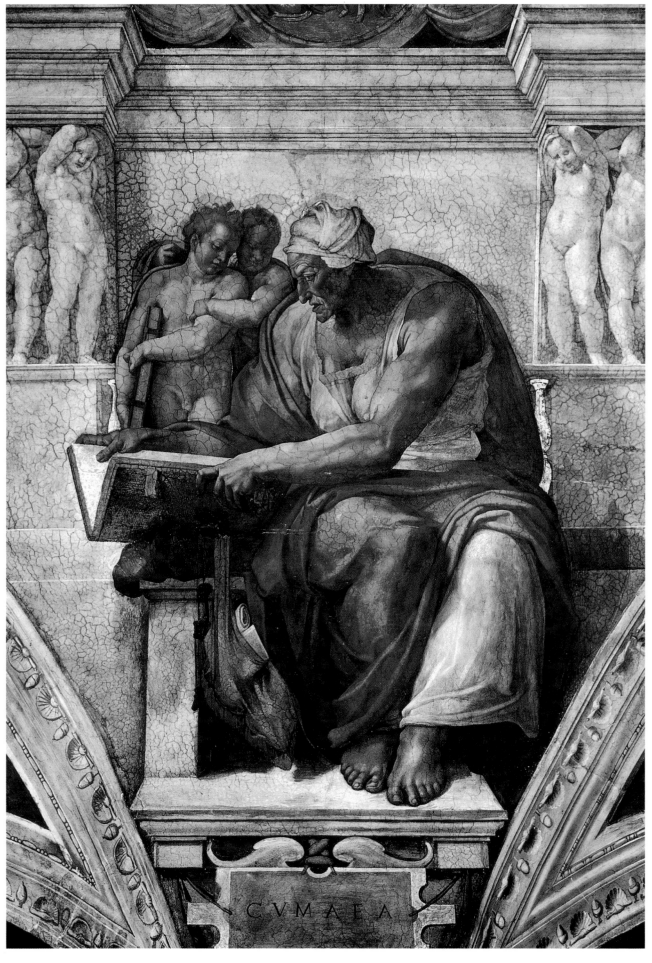

CVMAEA

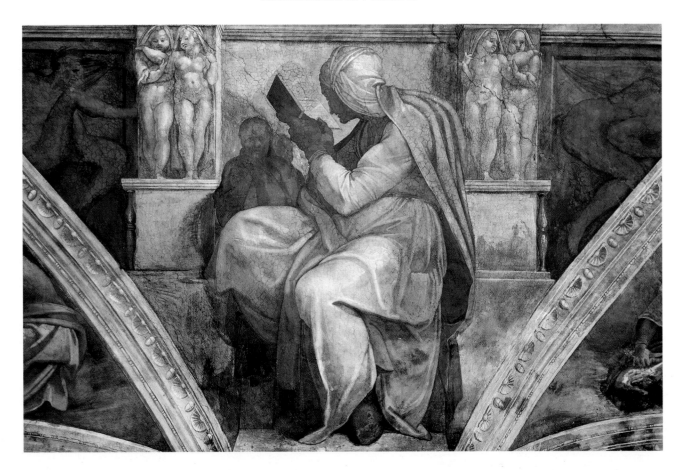

PLATE 48 opposite
The Cumaean Sibyl

PLATE 49 above
The Persian Sibyl

The presence of sibyls in the context of the Sistine ceiling needs some explanation. Sibyls in classical antiquity, and consequently pre-Christianity, inspired prophetesses, supposed to have been the mistresses or daughters of Apollo or merely his priestesses. According to different sources, they vary in number between one (Sibylla – hence the name) and ten, the most important being the Cumaean, Libyan, Delphic, Erythraean, Samian and Trojan; of these the most celebrated was the Sibyl of Cumae, Greece's earliest colony founded in 1050 B.C. near Naples.

Why Michelangelo has given them such importance in the scheme of the ceiling is somewhat obscure but they have become connected with much of the background of Jewish and Christian mythology and religion. Michelangelo includes the Delphic, Erythraean, Persian, Libyan and Cumaean Sibyls, and relates them to the Old Testament prophets Joel, Isaiah, Ezekiel, Daniel and Jeremiah. All the figures are forcefully drawn and have great physical presence, partly derived from Michelangelo's use of male models for female subjects.

the end wall of the Sistine Chapel to complement the ceiling and to replace paintings by Perugino and others which were out of sympathy with Michelangelo's work. A *Last Judgement* had already been chosen as a subject and Michelangelo began work on preparatory sketches. He was 60 years old and his programme was once more to be disrupted by the death of a pope.

It was probably at this time that Michelangelo met Tommaso Cavalieri, a young nobleman famous among his contemporaries for his great beauty. Michelangelo conceived such a passion for him and felt so rejuvenated that he wrote him letters and poems, inspired by the Platonic doctrine of love. Cavalieri became one of only two great passions of his life.

Clement VII died on 25 September 1534. The new Pope, Paul III, was a Farnese, a cultivated humanist and an assiduous patron of all arts who, consequently and not unnaturally, required Michelangelo to work exclusively for him. All the great figures – wealthy families, dukes and individual citizens, even popes of any cultural pretensions – wanted men of achievement about them, from philosophers and writers to artists and architects, often elevating them in the process to the highest level of society; even to the courts of kings, the fame of these notable historical figures lent considerable lustre. There

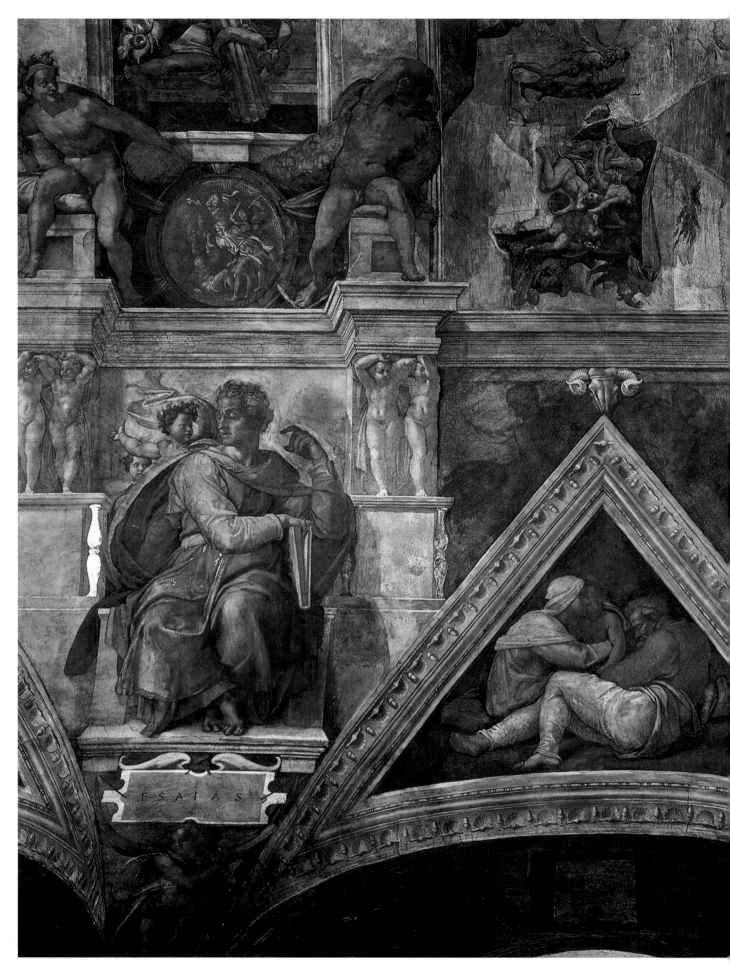

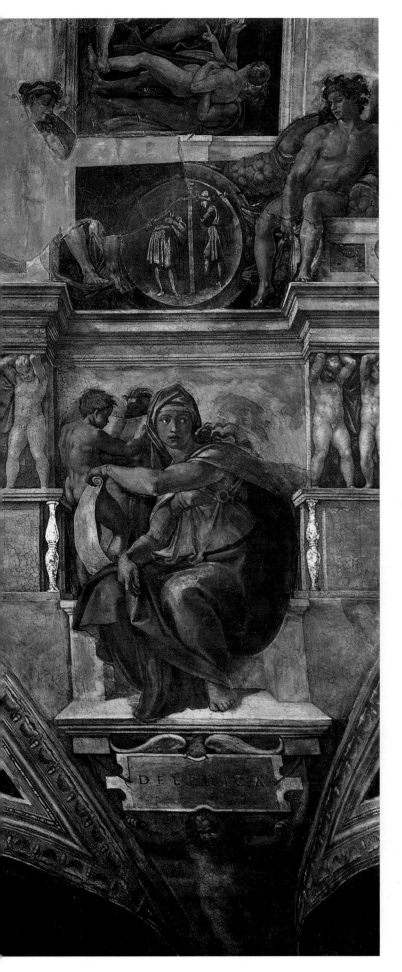

PLATE 50

The Prophet Isaiah and the Delphic Sibyl

As already mentioned, the coved ceiling was divided into separate scenes by an architecturally rendered framework into which, as well as the main subjects, a number of nude cherub figures and larger masculine figures (ignudi) are set. The architectural structure and supporting figures can be observed in this detail.

were not enough notables to meet the demand and competition for their services was consequently keen. It should also be noted that considerable advantages were bestowed on these creative and intellectual beings, not only financially, but in terms of general lifestyle and social contact with other kindred spirits. Some bidders, namely kings and popes, already had considerable advantages over their rivals, and particularly popes, since they had powers of excommunication – the ultimate threat.

Determined popes like Paul usually got their way; Paul continued with Clement's plan for the Sistine Chapel so that most of Michelangelo's first seven years in Rome were taken up with completing the new and colossal project – the fresco of the *Last Judgement* on the end wall over the altar, begun in 1536 after approval of the cartoons, and completed in October 1541. Although Michelangelo then wanted to finish the Julian tomb, a responsibility that continued to weigh on his mind, he was commanded to paint two further frescoes in the new Cappella Paolina, designed by Antonio da Sangallo the Younger, that Paul had caused to be constructed in the Vatican. These frescoes Michelangelo completed by 1550 and also managed to complete the tomb while working on them.

Although not as physically demanding as the Sistine ceiling, the *Last Judgement* remains in its damaged condition one of the best known single paintings in art.

It was while painting the *Last Judgement* that Michelangelo met Vittoria Colonna, widow of the Marchese de Pescara, a woman of deep religious piety whose influence served to reinforce Michelangelo's own faith. It was through her that he adopted the doctrine that God's existence can be justified by faith alone. He became

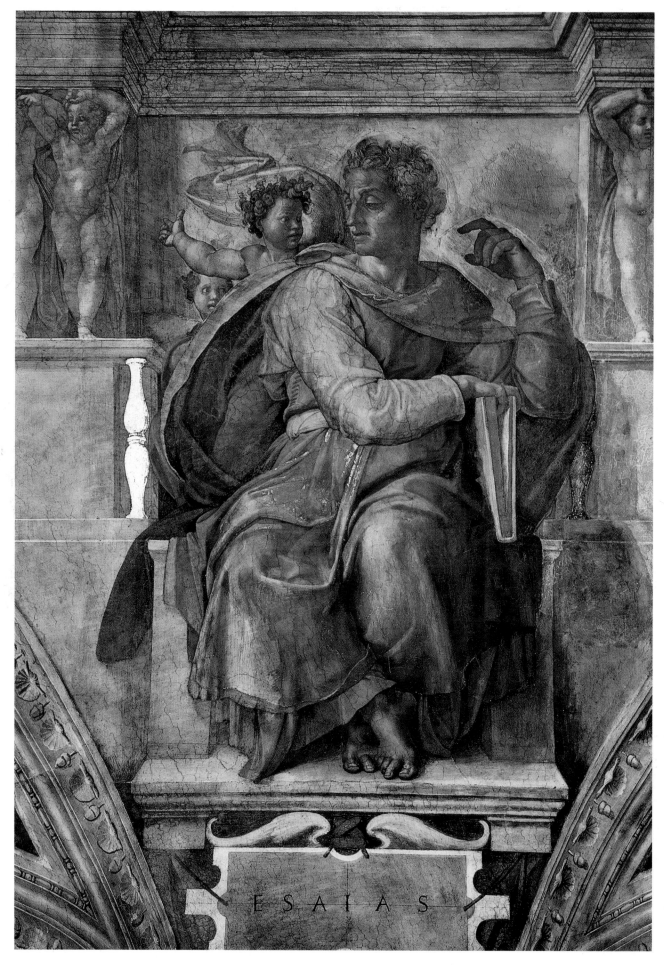

ESAIAS

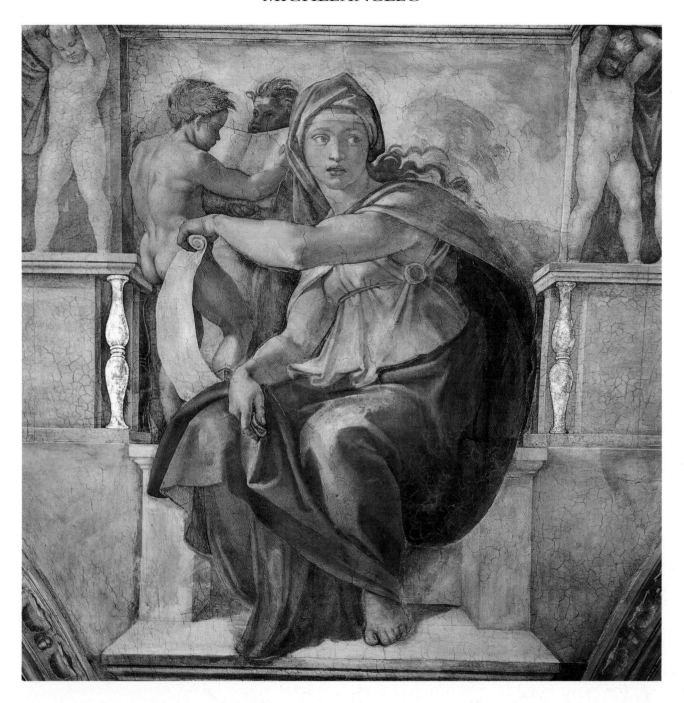

PLATE 51 detail opposite
The Prophet Isaiah

PLATE 52 detail above
The Delphic Sibyl

Unlike the figures of Isaiah and the Delphic Sibyl (opposite and above) who sit in quietly dignified poses, the figure of Ezekiel (plate 53) is full of tempestuous energy as if he would rather be actively proselytizing than bound by the restraints imposed on him as a sitter in a portrait. Some of Michelangelo's terribilità escapes in the painting.

devoted to her, and his many poems, religious in content and accompanied by drawings of religious subjects, testify to her effect on him. She was the second person for whom Michelangelo had felt an abiding passion; as already noted, Tommaso Cavalieri was the first.

Pope Paul III, as previously mentioned, was a dedicated patron of the arts and humanities, but was also a great admirer and supporter of the Society of Jesus. Paul died in 1549 and was succeeded by Julius III, also a strong Jesuit supporter, and Michelangelo offered Ignatius Loyola, founder of the order, a design and model, free of charge, for a new mother church, the Gesù; although it was never realized, the offer does indicate Michelangelo's deep

PLATE 53
The Prophet Ezekiel

commitment to religion and devotion to the Church.
During Julius' pontificate, Michelangelo made for his own
tomb a sculpture of the Deposition (removal of Christ's
body from the cross). Julius was followed by another
short-lived pope, Paul IV (1555–59), a man of very
different character, who consolidated the Inquisition and
its rigorous régime of persecuting heretics. Michelangelo
was himself denounced as a heretic and the pope ordered
that the many naked figures in his *Last Judgement* be
repainted with 'loin-cloths' by Daniele da Volterra
(thereafter known as Daniel the Breeches-maker),
nakedness in proximity to an altar being felt, perhaps
reasonably, to be inappropriate.

Pope Paul III, who had presided over a brilliant and
intellectual court, had given the papacy a new status in his
reconvention of the Council of Trent, consolidating the
counter-Reformation and establishing a strong new papal
authority. At this time, in 1546, Michelangelo was already
getting on in years, but the pope now gave him important
architectural work – in fact, the most significant large-scale
architectural project in existence at that time, the
Christian and civic centres of Rome, St. Peter's and the
Capitol, which together, when realized, had a dramatic
effect on the physical appearance of the city which is still
visible today.

The background to this work is of great importance in
the study of Michelangelo's achievement. His major
pictorial and sculptural projects had been completed and
he had undertaken important architectural commissions,
such as the Medici chapel and the Laurentian library in
Florence; but these last two architectural projects were of
a different order. Firstly, St. Peter's was the mother church
of Christianity, built on the traditional site of St. Peter's
martyrdom and was the symbolic location where, in A.D.
800, church and state were united through the coronation
of Charlemagne by Pope Leo III. Secondly, the Capitol
was intended to represent a secular centre for a modern
Rome and to replace the buildings remaining from the
great Roman Imperial days, now in a state of serious
disrepair and neglect. This was a time when elements of
classical architecture taken from antiquity were again being
viewed with enthusiasm and were beginning to be
adopted. It should be remembered that during the Middle

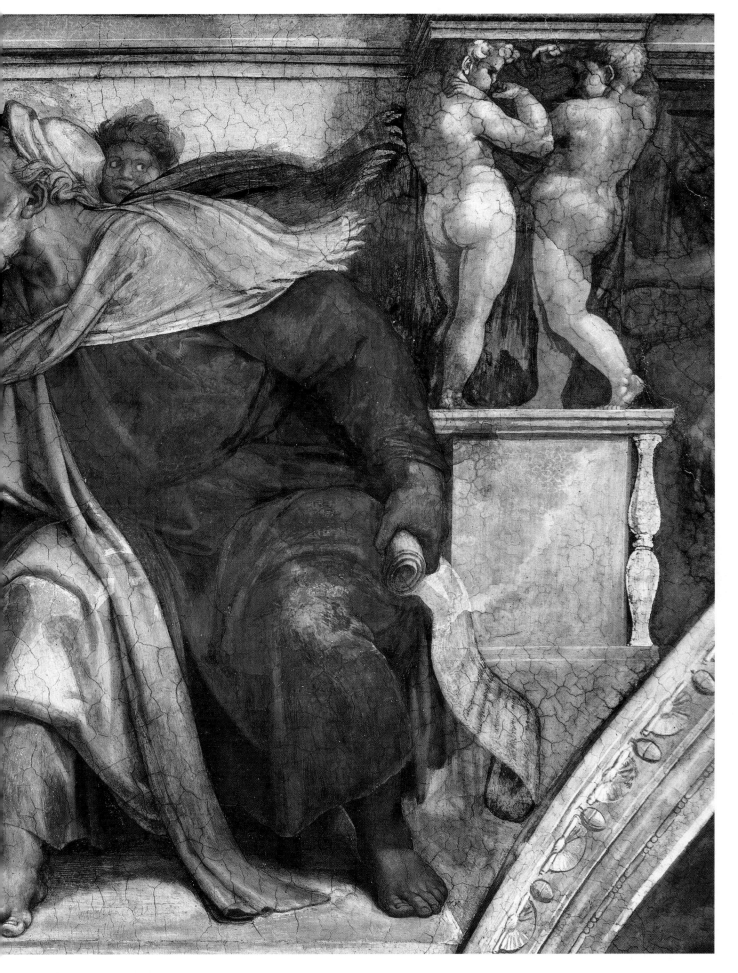

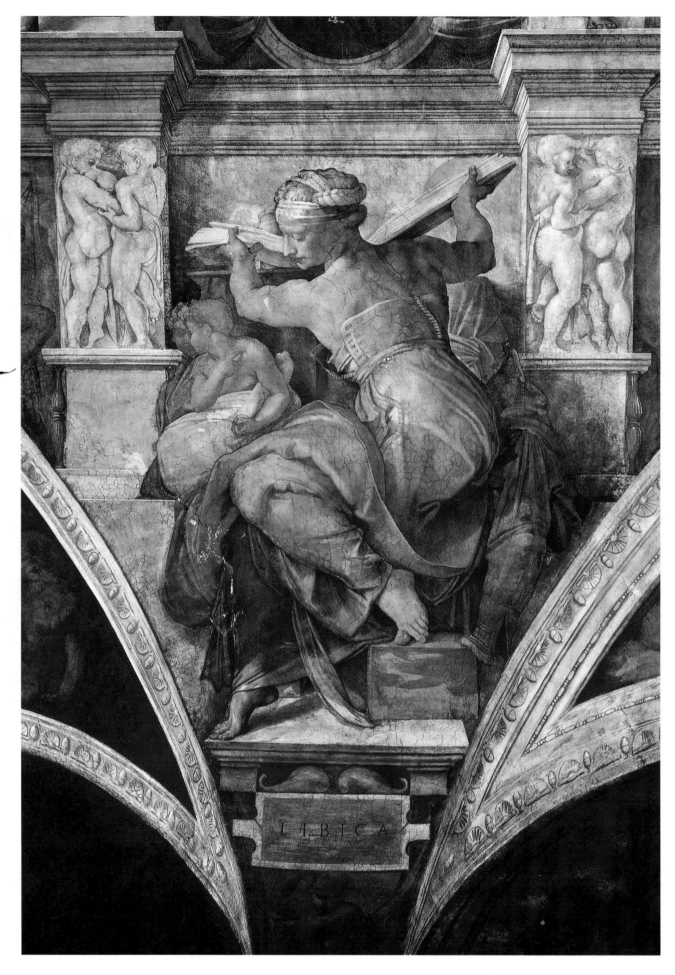

LIBICA

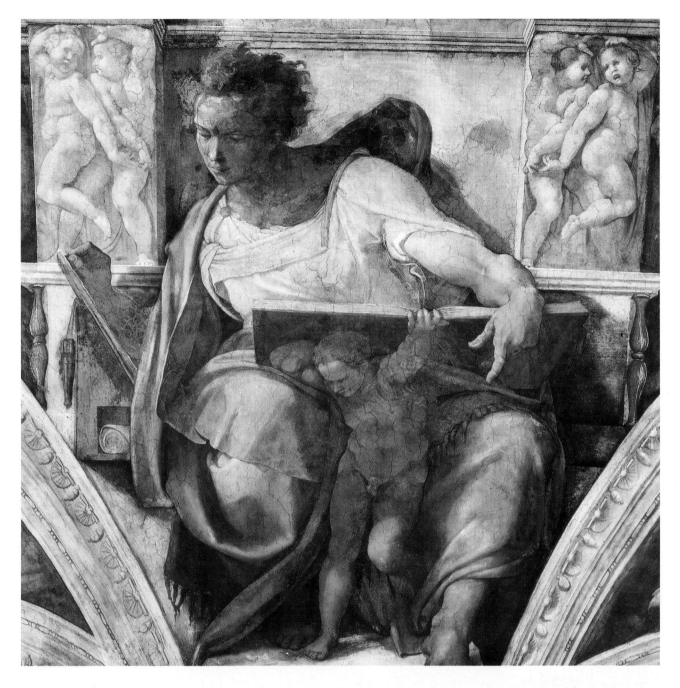

PLATE 54 opposite
The Libyan Sibyl

This is one of Michelangelo's most elegantly drawn figures for which he did a number of studies, including the one depicted in plate. (See also plate 38.)

PLATE 55 above
The Prophet Daniel

Ages, when Christianity was represented by a new and different architectural form, the classical buildings of ancient Rome were little valued and were frequently allowed to decay into rubble when stone from them would be taken for newer buildings, such as churches.

It is an amazing tribute to the respect, confidence and faith in his abilities accorded to Michelangelo that, at the age of 72, both great architectural projects should have been given to him.

The rebuilding of the old basilica constructed by Constantine over the supposed site of St. Peter's martyrdom and burial had often been considered over the centuries, but it was not until the great creative energy of the Renaissance, allied to the personal ambitions of popes,

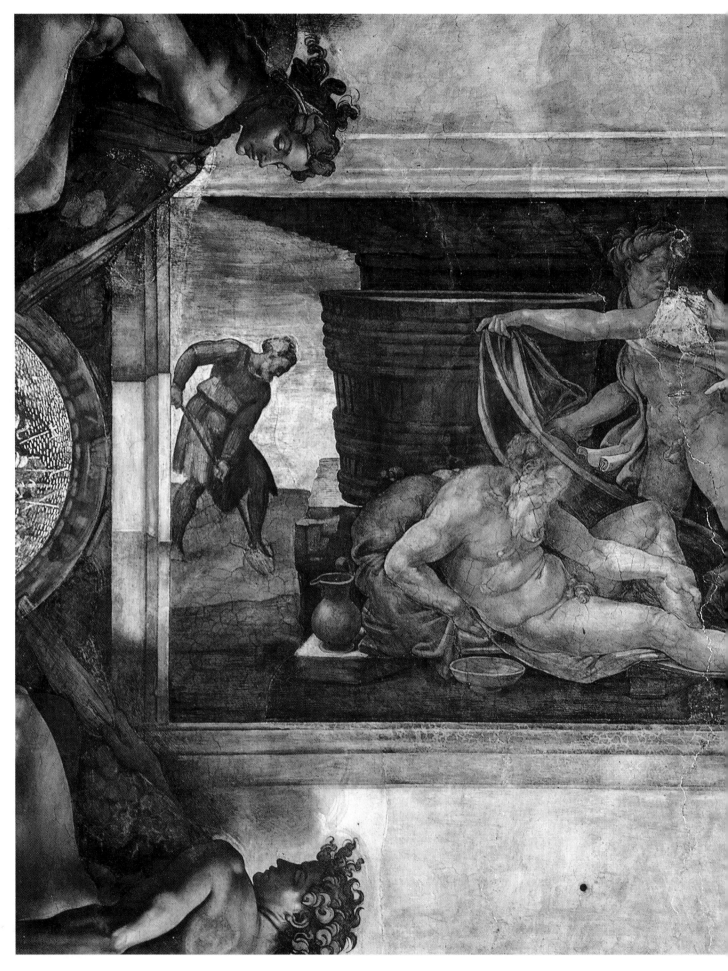

PLATE 56
The Drunkenness of Noah

The first panel that one encounters on entry, The Drunkenness
of Noah, *leads backwards into the historical sequence through*
The Fall of Man *to* God Separating the Light from the
Darkness *in the nine major scenes following the main central line
of the vault. The story of Noah is of seminal importance in the
Old Testament sequence. It represents a warning and an
opportunity and is an appropriate final image in Michelangelo's
programme. He has depicted the subject in one of the smaller
panels. For those unfamiliar with the episode, it depicts the period
after the Deluge when Noah planted a vineyard. He drank too
much wine and lay down in a drunken stupor. His son Ham
found him and summoned his brothers Shem and Japheth who,
shielding their eyes, covered Noah's nakedness with a cloak. The
pointing figure is Ham, and his brothers are looking away from
the body of Noah. The importance of the story lies in the
resultant disgrace of Ham (for seeing his father naked) and the
advance of his brothers for thus creating the differing ranks of the
tribes of Israel.*

that practical steps were taken. The first pope to tackle the
problem was Nicholas V, elected in 1447. He had
enormous ambitions for rebuilding in Rome, centred on
St. Peter's, and was the founder of the Vatican library.
Nevertheless, even he had not the courage to demolish a
building that represented the whole of Christian history;
thus, his intention was to build a new church around the
old basilica, with the result that the old remained in use
while the building of the new was in progress. Work on
the new St. Peter's began, in consequence, on a huge scale
which determined its future size and made it the greatest
church in Christendom and the largest single building
enterprise undertaken in Europe.

 Although work was begun under Nicholas, it was not
until the papacy of Julius II, Michelangelo's great patron,
that building began in earnest. Julius entrusted the design
to Donato Bramante and made the bold but necessary
decision to demolish the old Constantinian structure. The
design approved, the foundation stone was laid by the
pope in April 1506. When Julius died in 1514, and
Bramante in the following year, the new building was well
advanced and the old building demolished. However, little
serious construction work was done for the next 30 years.

 The appointment of Michelangelo in 1546 as
architect-in-chief of St. Peter's came when he was still

PLATE 57
The Creation of Eve

One of the small panels, this shows Eve emerging from the body
of Adam and being blessed by the Almighty. It will be noticed
that the scene is surrounded by four ignudi of somewhat
androgynous character.

PLATE 58 overleaf
The Deluge

The first of the larger panels, this depicts the Flood with the
Dove framed on the top of the Ark of the Covenant.
Michelangelo's art is expressed largely through the human form
and this is strongly revealed here. The earth and the elements are
treated cursorily and all the emotional turbulence of the scene is
expressed through the actions of the figures.

working on the Pauline chapel frescoes; again he was
given work that was not his first choice, sculpture, but the
opportunity was so important that he accepted, somewhat
mollified when the pope gave him 'full authority to
change the model, form and structure at will'.
Michelangelo, on his part, insisted on working without
payment and this, together with the pope's authority, gave
him great power as well as helping to thwart criticism by
his many professional enemies, both real and imagined. (It
will be recalled that Michelangelo was a morose, secretive
and suspicious character.)

It was only through his own will-power and immense
energy that Michelangelo was able to continue with this
enormous task. However, it will be remembered that he
had also received another great commission for the design
for the Capitol. From the time of Imperial Rome, and
continuing through the Middle Ages, the Capitol had been
the centre of the political life of Rome from which the
city and the world were governed, having a symbolic role
as the perceived centre of the universe. This
overwhelming sense of the Capitol's importance seems to
have inspired Michelangelo. The equestrian statue of
Marcus Aurelius, emperor from A.D. 121–180 and a wise
and revered ruler, stood on a plinth in the square from
1538 and it became a central element in Michelangelo's
plan for the site (plate 32). He designed a new elliptical
plinth and around it created a large oval piazza framed by
three symmetrically-related buildings, approached from
below by a flight of steps linking the piazza to the city
below. The sculpture of Marcus Aurelius, the finest bronze

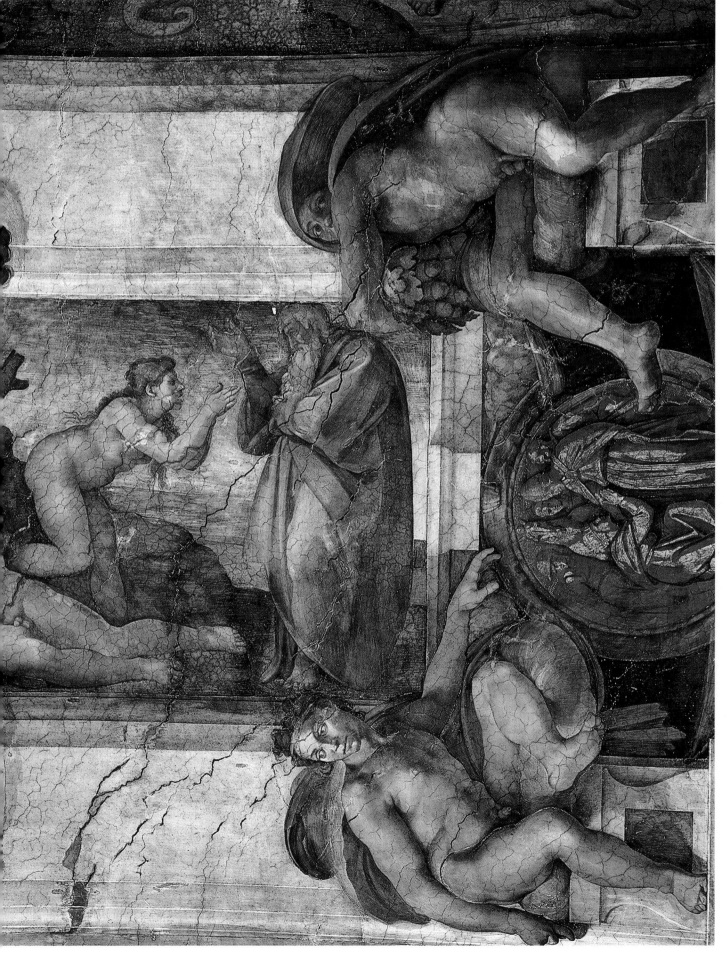

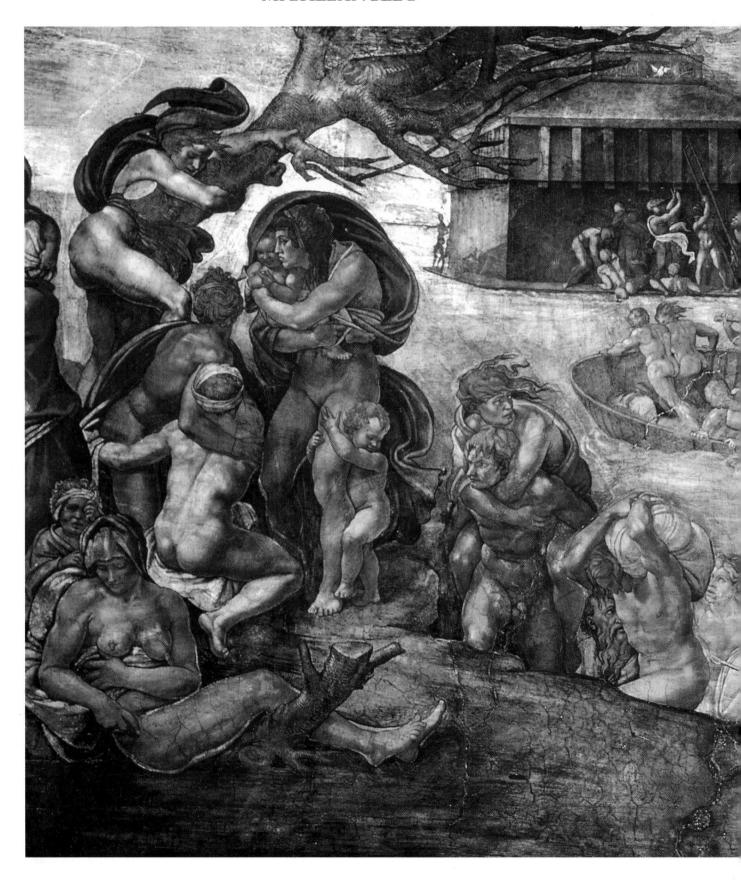

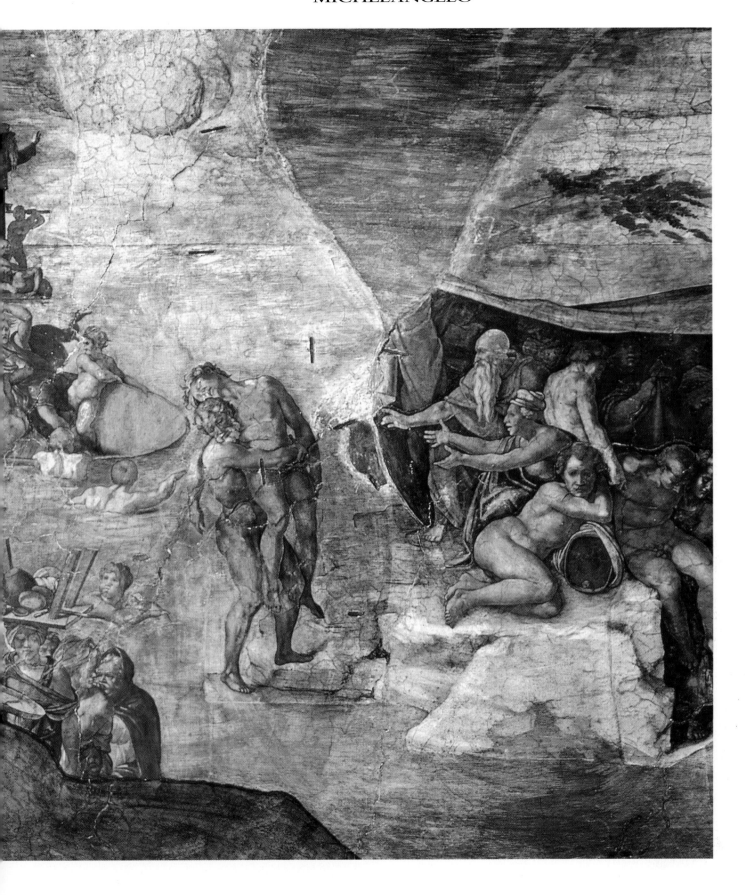

PLATE 59
The Fall of Man

This large panel shows the Temptation by the Serpent and the Expulsion of Adam and Eve from the Garden of Eden, an interesting example of the time element in Renaissance pictorial storytelling.

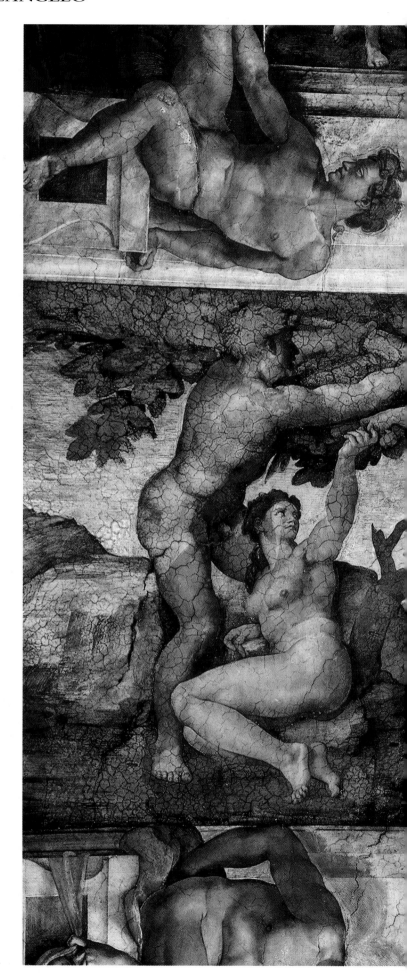

surviving from antiquity, dominates the square, the emperor's arm outstretched in a gesture of peace, the whole seeming to exude an atmosphere of calm control. Although the entire complex was designed by Michelangelo, only the Palazzo dei Conservatori was begun when Michelangelo died; but the plans he made were followed in the succeeding century.

Pius IV, who was pope in 1564, also gave Michelangelo important architectural projects which included the conversion of the Baths of Diocletian into the church of Santa Maria degli Angeli. His last architectural work was the design for the Sforza chapel in the church of Santa Maria Maggiore (plate 35).

Michelangelo died in Rome on 18 February 1564, less than three weeks away from his 90th birthday. Present at his death were Tommaso Cavalieri, Daniele da Volterra and two doctors. His body, according to his wishes, was taken to Florence by his nephew Leonardo – secretly, because it was intended that his body should rest in Rome. His funeral took place on 14 July in the church of San Lorenzo and his tomb in Santa Croce was designed by Giorgio Vasari, his devoted admirer and biographer.

It is singularly difficult to summarize the life of such a man. Indeed, one wonders how one man, even in a life of 90 years duration, could have achieved so much in spite of the many obstacles regularly set in his path. Even from this brief survey, one can see that his life was one of frustration as a result of the many changes made by successive popes, and the fact that he was often required to work in art forms for which he had less enthusiasm. He always described himself as a sculptor and, given the opportunity, would not have painted or worked as an architect. We may be grateful that his patrons made such demands of him, which undoubtedly exacerbated his feelings of anger and resentment. It is the measure of his genius that, when obliged to create works in the unwished for arts of painting or architecture, he nevertheless produced works of the greatest genius in both these disciplines, as well as being the greatest sculptor of the Renaissance and perhaps of all time.

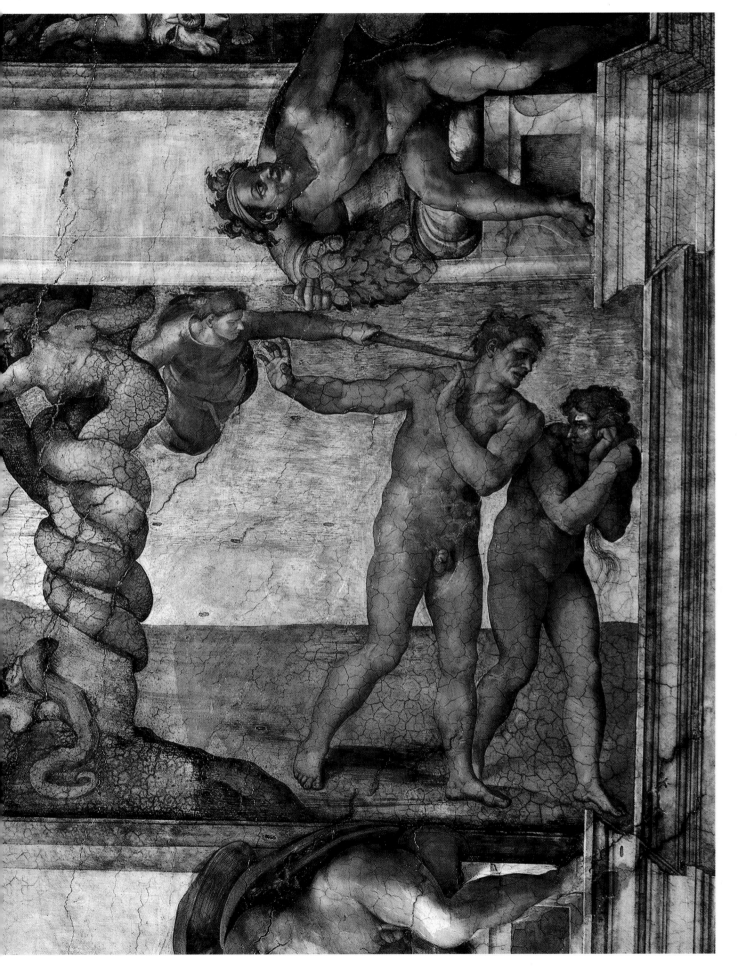

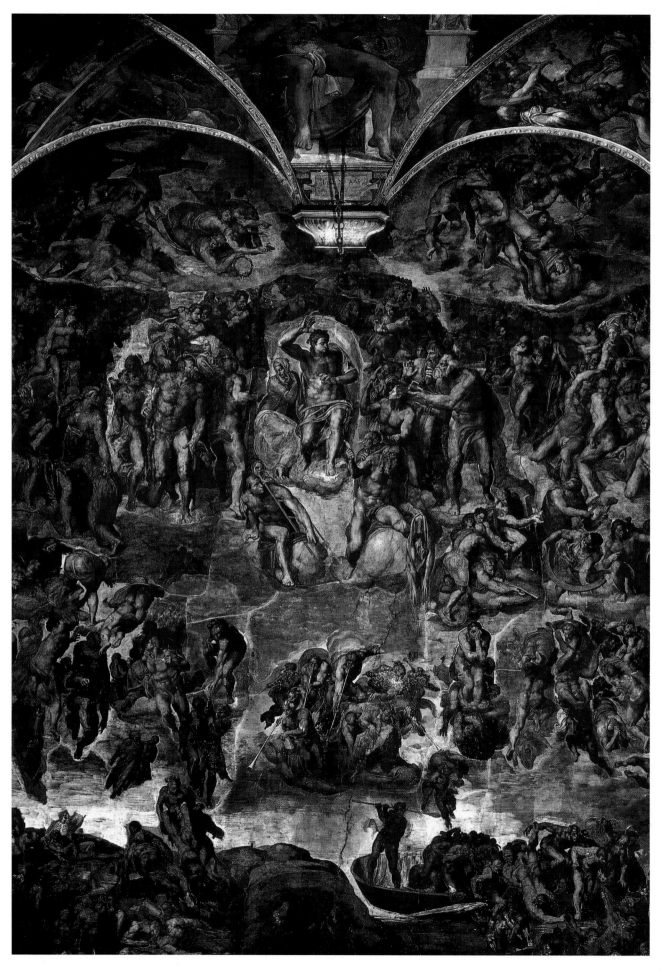

PLATES 60 and 61 (details opposite and below) and
62 overleaf

The Last Judgement (1535–41)

Fresco, 55 x 43ft 7 inches (16.76 x 13.28m)

*The original commission received by Michelangelo was for only
the upper part of the end wall of the Sistine Chapel. The lower
part contained paintings by Perugino and after fire damage in
1525 the upper part needed a new work. Michelangelo was
inhibited by the idea of a partial work, a Resurrection, and he
introduced a new plan for a Last Judgement which was agreed;
the existing frescos were destroyed, two windows blocked in, and
the wall replastered. The painting was made with only one
assistant who mixed colours.*

*A number of Michelangelo's contemporaries have been
identified in the painting, notably the poet Pietro Aretino as St.
Bartholomew holding his own flayed skin in which Michelangelo
has portrayed himself (see to the right of and below the figure of
Christ). Vittoria Colonna, Tommasso Cavalieri and Dante have
also been tentatively identified. Christ the Judge is centrally
placed with Mary to His left and St. Peter, holding the Key of
Heaven, to His right (plates 60 and 62). The Resurrected Souls
rise on the left (plate 61 below) and Hell is depicted with
Charon's boat crossing the Styx at the bottom right edge of
plate 60.*

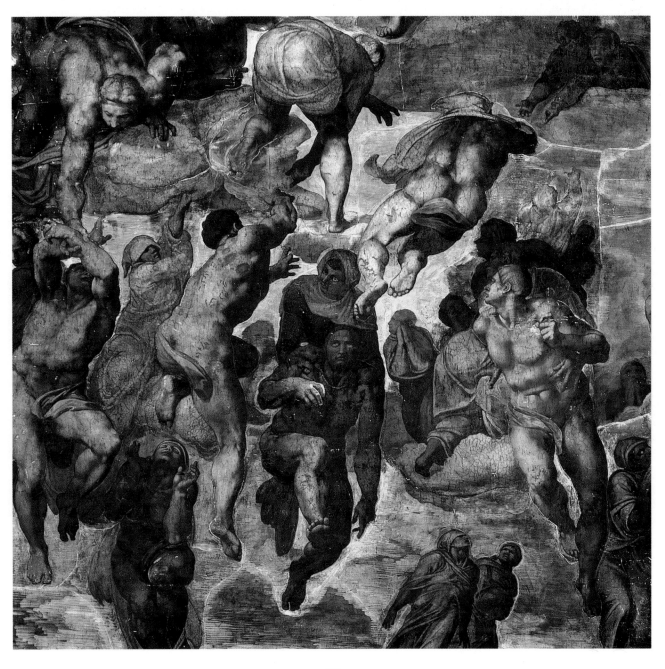

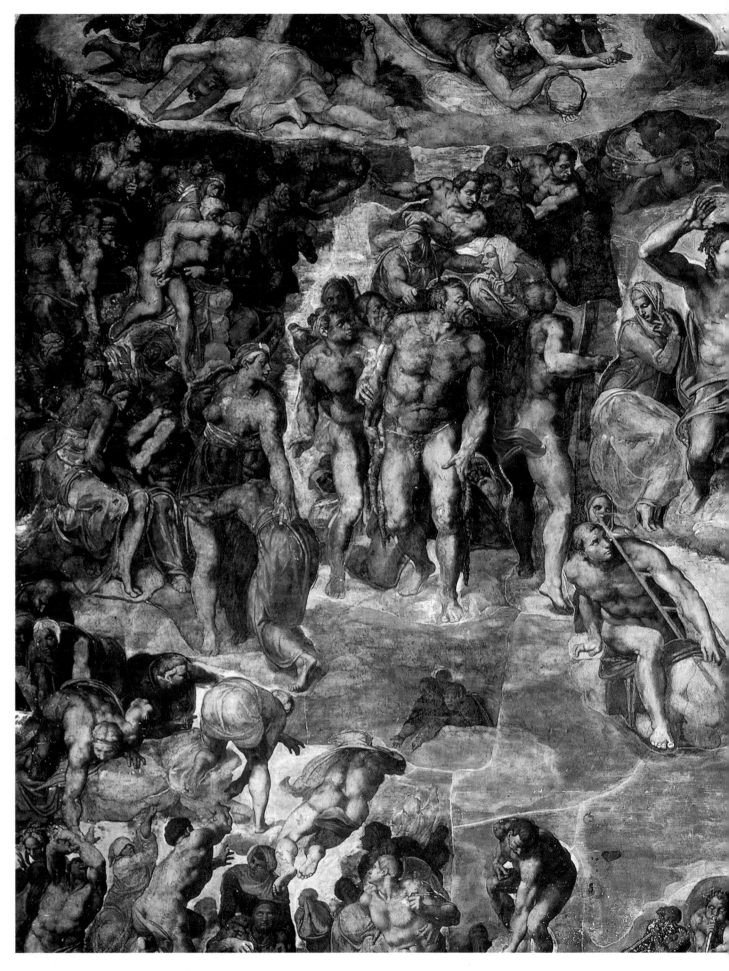

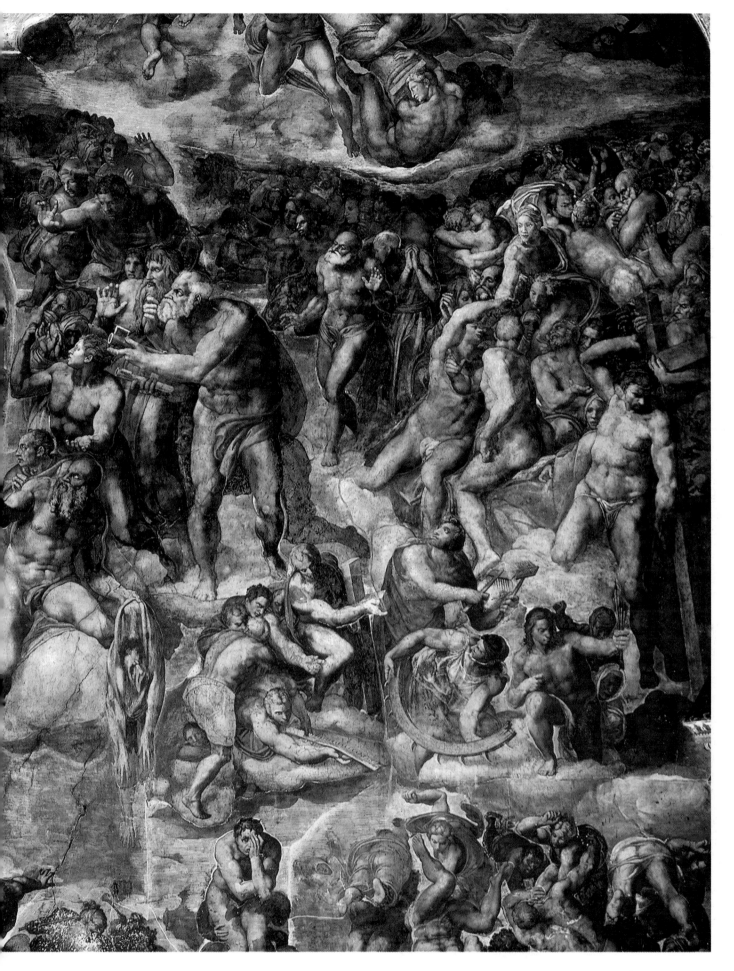

ACKNOWLEDGEMENTS

The Publishers wish to thank the following for providing photographs, and for permission to reproduce copyright material. While every effort has been made to trace and acknowledge copyright-holders, we wish to apologize should any omissions have been made.

Pietà

Basilica San Pietro, Vatican, Rome

Bacchus

*Museo Nazionale del Bargello, Florence/
Alinari/Giraudon, Paris*

David

*Uffizi Gallery, Florence/
Louvre/Alinari/Giraudon, Paris*

Doni Tondo

Uffizi Gallery, Florence/Trewin Copplestone

**Madonna and Child with St. John
(The Taddei Tondo)**

Royal Academy of Arts/Trewin Copplestone

**Figure of Moses (Tomb of Pope
Julius II)**

*San Pietro in Vincoli, Rome/
Trewin Copplestone*

Dying Slave

Louvre/Lauros/Giraudon, Paris

Rebellious Slave

Louvre/Lauros/Giraudon, Paris

Victory

Florence, Palazzo Vecchio/Trewin Copplestone

Pietà del Duomo

*Florence Academy of Fine Arts/
Trewin Copplestone*

Pietà (Rondanini)

*Castello de Sforza Museum, Milan/
Lauros/Giraudon, Paris*

Pietà (Palestrina)

*Florence Academy of Fine Arts/Sonia Halliday
Photographs, Photo Jane Taylor*

Brutus

*Museo Nazionale del Bargello, Florence/
Alinari/Giraudon, Paris*

**Tomb of Lorenzo de' Medici with
supporting figures of Twilight and
Dawn, The Medici Chapel, Church of
San Lorenzo, Florence**

Alinari/Giraudon, Paris

**Tomb of Giuliano de' Medici with
supporting figure of Night and Day,
The Medici Chapel, Church of San
Lorenzo, Florence**

Bridgeman Art Library, London

**Drawing of tomb for Lorenzo de'
Medici**

Museé du Louvre/Giraudon, Paris

**Interior view of the Medici Chapel,
Church of San Lorenzo, Florence**

Bridgeman Art Library, London

Vestibule of the Laurentian Library

Bridgeman Art Library, London

**View along the reading-room of the
Laurentian Library**

Bridgeman Art Library, London

Cathedral Church of St. Peter, Rome

Bridgeman Art Library, London

Interior of St. Peter's Dome

Trewin Copplestone

St. Peter's Dome (drawing)

Musée des Beaux-Arts, Lille

Piazza del Campidoglio, Rome

Bridgeman Art Library, London

Piazza del Campidoglio, Rome

Trewin Copplestone

Façade of the Farnese Palace, Rome

Bridgeman Art Library, London

Façade of the Farnese Palace, Rome

Bridgeman Art Library, London

Virgin and Child

Louvre/Giraudon, Paris

The Alchemist

*British Museum ·London/Alinari/
Anderson/Giraudon, Paris*

**Study of the Libyan Sibyl for the
Sistine Chapel ceiling**

*Metropolitan Museum, New York/Trewin
Copplestone*

Head of Adam

*British Museum London/Alinari/
Anderson/Giraudon, Paris*

Head of a satyr

Louvre/Giraudon, Paris

Study of head

*Casa Buonarroti, Florence/
Alinari/Brogi/Giraudon, Paris*

**Study for the Sacrifice of Isaac by
Abraham**

*Casa Buonarroti, Florence/
Alinari/Brogi/Giraudon, Paris*

Anatomical study

*Casa Buonarroti, Florence/
Alinari/Brogi/Giraudon, Paris*

**Anatomical study: a man kneeling,
back facing**

Casa Buonarroti, Florence/

Alinari/Brogi/Giraudon, Paris

The Sistine Chapel

*Sistine Chapel, Vatican, Rome/
Alinari/Giraudon*

Sistine Chapel vault

*Sistine Chapel, Vatican, Rome/
Alinari/Giraudon*

The Creation of Adam

*Sistine Chapel, Vatican, Rome/
Alinari/Giraudon*

The Cumaean Sibyl

*Sistine Chapel, Vatican, Rome/
Alinari/Giraudon*

The Persian Sibyl

*Sistine Chapel, Vatican, Rome/
Alinari/Giraudon*

**The Prophet Isaiah and the Delphic
Sibyl**

*Sistine Chapel, Vatican, Rome/
Alinari/Giraudon*

The Prophet Isaiah

*Sistine Chapel, Vatican, Rome/
Alinari/Giraudon*

The Delphic Sibyl

*Sistine Chapel, Vatican, Rome/
Alinari/Giraudon*

The Prophet Ezekiel

*Sistine Chapel, Vatican, Rome/
Alinari/Giraudon*

The Libyan Sibyl

*Sistine Chapel, Vatican, Rome/
Alinari/Giraudon*

The Prophet Daniel

*Sistine Chapel, Vatican, Rome/
Alinari/Giraudon*

The Drunkenness of Noah

*Sistine Chapel, Vatican, Rome/
Alinari/Giraudon*

The Creation of Eve

*Sistine Chapel, Vatican, Rome/
Alinari/Giraudon*

The Deluge

*Sistine Chapel, Vatican, Rome/
Alinari/Giraudon*

The Fall of Man

*Sistine Chapel, Vatican, Rome/
Alinari/Giraudon*

The Last Judgement

*Sistine Chapel, Vatican, Rome/
Alinari/Giraudon*